SUFFOLK PLACES BEHIND THE FACES

To Alex

Best Wishes

John Ling

John Ling

First published 2024

Amberley Publishing
The Hill, Stroud
Gloucestershire, GL5 4EP

www.amberley-books.com

Copyright © John Ling, 2024

The right of John Ling to be identified as the Author of this work has been asserted in accordance with the Copyrights, Designs and Patents Act 1988.

ISBN 978 1 3981 1616 0 (print)
ISBN 978 1 3981 1617 7 (ebook)

All rights reserved. No part of this book may be reprinted or reproduced or utilised in any form or by any electronic, mechanical or other means, now known or hereafter invented, including photocopying and recording, or in any information storage or retrieval system, without the permission in writing from the Publishers.

British Library Cataloguing in Publication Data.
A catalogue record for this book is available from the British Library.

Typesetting by SJmagic DESIGN SERVICES, India.
Printed in Great Britain.

Contents

Introduction ... 5
1. Suffolk's Historical Royal Connections 6
 Saint Edmund .. 6
 Anne Boleyn .. 8
 Mary Tudor, Queen of France 10
 Mary I of England versus Lady Jane Grey 11
 James II .. 14
 The Duleep Singh Family .. 16
 Princess Caroline Murat ... 17
2. Other Suffolk Historical Characters 19
 Cardinal Thomas Wolsey ... 19
 Thomas Gainsborough ... 21
 John Constable .. 23
 Elizabeth Garrett Anderson ... 24
 Alfred Munnings .. 27
3. Battles, Rebellions and Other Historical Happenings ... 29
 Simon Sudbury and the Peasants' Revolt 29
 The Bigod Barons of Bungay and the Great Fire 32
 The Battle of Sole Bay ... 36
 The Battle of Fornham ... 38
 The Hadleigh Gang and Other Suffolk Smugglers .. 40
4. Literary Locations and Inspirations 43
 Charles Dickens: Pickwick and Copperfield 43
 George Orwell: The Suffolk Sojourns 44
 George Crabbe: Suffolk's 'Forgotten' Poet 47
 Thomas Nashe: Controversial Playwright and 'Obscene' Poet? ... 49

 The Strickland Family of Authors — 51
 Henry Rider Haggard and Other Bungay Connections — 53
 J. M. Barrie: *Peter Pan* and Thorpeness — 54
 P. D. James: Adam Dalgliesh and Other Stories — 55
 Ruth Rendell: Suffolk Inspirations — 56
 W. G. Sebald in Suffolk — 57
 Other Literary Connections — 58

5. **Twentieth-century Personalities** — 60
 Benjamin Britten — 60
 Christopher Cockerell — 62
 David Frost — 63
 Cartoonist Giles — 64
 Maggi Hambling — 66
 Other Modern Personalities — 67

6. **Film and Television Locations and Connections** — 68
 Film and TV Personalities with Suffolk Links — 68
 Don't tell him, Pike! – *Dad's Army* Secrets — 71
 Lovejoy: Antiques and Antics — 73
 Yesterday (2019 film) — 74
 Lavenham: From John and Yoko to Harry Potter — 75
 Ipswich Area — 77
 Lowestoft Area — 78
 Southwold Area — 80
 Bury St Edmunds — 83
 Other Locations — 84

7. **Music Links and Inspirations** — 87
 The Aldeburgh Festival — 87
 The Latitude Festival — 88
 Ed Sheeran — 89
 Brian Eno — 91
 The Darkness — 92
 Other Connections — 93

Bibliography — 95
Acknowledgements — 96

Introduction

Suffolk Places behind the Faces explores some of the locations connected with the county's best-known historical figures, historical events, literary inspirations, films, television programmes and music. It is intended to appeal to all those interested in visiting places where history was made or which formed the backdrop to classic movies and television shows.

Suffolk has many connections with royalty, starting with a ninth-century warrior king named Edmund. It also played a key role in the accession of Mary I of England at the expense of Lady Jane Grey, despite the fact that Jane had Suffolk links. The county also has associations with Anne Boleyn, Queen Mary of France and other royals.

Historical events include the Peasants' Revolt, the battles at Fornham and Sole Bay, plus the exploits of the Bigod dynasty of fighting barons and the much-feared Hadleigh Gang.

Famous and influential people born in Suffolk include churchmen Cardinal Thomas Wolsey and Archbishop Simon Sudbury, and artists Thomas Gainsborough, John Constable and Alfred Munnings. Pioneering doctor and surgeon Elizabeth Garrett Anderson was raised in Aldeburgh and is buried in the local churchyard, as is twentieth-century classical composer Benjamin Britten. Actors Ralph Fiennes, Bob Hoskins, Robin 'Poldark' Ellis and June 'Dot Cotton' Brown were all born in the county. Broadcaster Sir David Frost, hovercraft inventor Sir Christopher Cockerell, cartoonist Giles, national treasure Delia Smith and, of course, present pop royalty Ed Sheeran all have strong associations with Suffolk.

Best-selling authors Charles Dickens and George Orwell found inspiration for some of their characters and plots in Suffolk. Orwell wrote several books while living in Southwold during the 1930s and took his pen name from the river that meanders through the county. P. D. James and Ruth Rendell also had homes in Suffolk, and Peter Pan creator J. M. Barrie had connections with Thorpeness. Historical author Agnes Strickland – perhaps the best known of a famous family of writers – spent much of her life in the county and is buried in Southwold. The best-known book by acclaimed German author W. G. Sebald is based on a walking tour of Suffolk.

Films at least partly shot in Suffolk include *Harry Potter and the Deathly Hallows*, *Yesterday*, *Lara Croft: Tomb Raider*, *Fourth Protocol*, *The Living Daylights* and *Witchfinder General*. Television programmes include *Dad's Army*, *Lovejoy*, *The Crown* and *Detectorists*.

Where possible, the book includes illustrations and photographs of historical figures, but copyright restrictions often prohibit the commercial use of paintings in collections and images of living or recently deceased people. For similar reasons, it is not always possible to use photographs of specific places mentioned in the text.

1. Suffolk's Historical Royal Connections

Saint Edmund

Twelve centuries after his life and death, it is almost impossible to separate the saint to whom many miracles have been attributed from the historical East Anglian king who legend tells us was killed by the invading Danes.

Little is known about the real man behind the myths. Eleventh- and twelfth-century writers retold earlier stories but often embellished them, so it is difficult to tell fact from fiction. It is traditionally said that Edmund was born in 841 in the Suffolk village of Bures and became King of East Anglia on 25 December 855. The date of his death is usually given as 20 November 869 or 870. He may have died in battle or was captured and executed by his enemies. According to an old tale, he hid beneath Goldbrook Bridge in Hoxne, Suffolk, but was betrayed by a wedding party passing overhead and handed over to the Vikings. Before he died, Edmund put a curse on the bridge, which was last rebuilt in 1878. A statue stands proudly on top of St Edmund's Hall nearby and the place where he is said to have died is marked by a stone monument in a field. Another statue can be seen above the main porch of St Edmund's Church in Southwold. Three canopied reliefs above the doorway of St Edmund's Church in Bungay depict his capture, execution, and the discovery of his severed head.

After his body was moved to Bury St Edmunds, claims of miracles began to circulate and his shrine became a place of pilgrimage. A man's sight and a woman's speech were

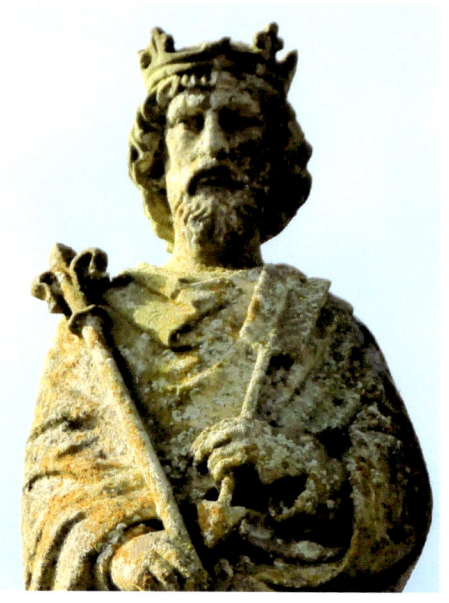

Statue of St Edmund, St Edmund's Hall, Hoxne.

St Edmund's monument, Hoxne.

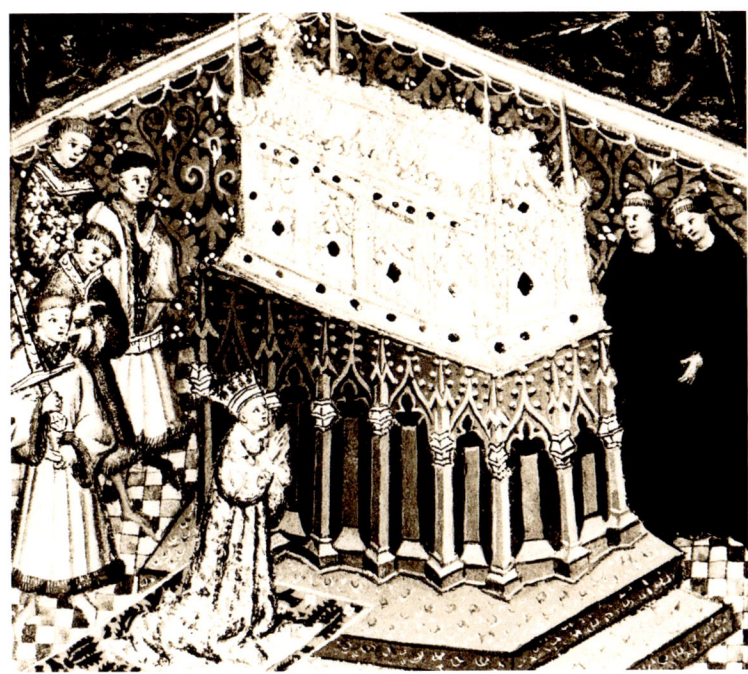

Henry IV worshipping at the shrine of St Edmund. (Wellcome Collection, CC BY-4.0)

restored and the saint's body was alleged to be fresh hundreds of years after his death, with his hair and fingernails still growing. Several kings including Canute and Henry IV prayed at Edmund's grand shrine before its destruction in 1539. Despite many theories, the whereabouts of his earthly remains are unknown. He may still lie among the ruins of Bury Abbey, though there is a story that his bones were stolen in the thirteenth century and taken to France.

Anne Boleyn

Although not primarily associated with Suffolk, Anne Boleyn was no stranger to the county and some believe that a part of her still rests here.

Anne's aunt Amy (also known as Amata or Jane) lived at Erwarton Hall, situated south of Ipswich, with her husband, Sir Philip Calthorpe. The future Queen of England is said to have frequently visited her aunt and uncle both as a child and as a young woman. Henry VIII is believed to have also visited Erwarton Hall as part of his eventually successful quest to woo her, despite being married to his first wife, Catherine of Aragon.

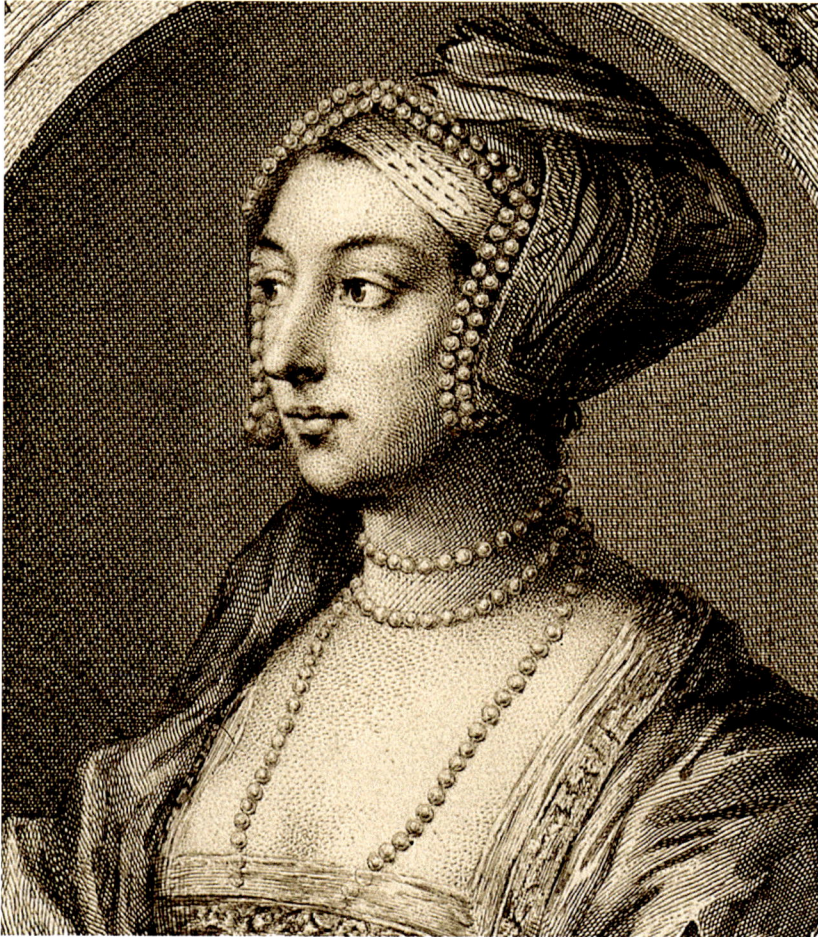

Queen Anne Boleyn. (From an engraving by J. Houbraken, 1738, after H. Holbein the Younger; Wellcome Collection, PDM 1.0)

If a local legend is to be believed, Anne Boleyn's heart was secretly buried in an alcove in the north aisle of St Mary's Church, Erwarton. She is said to have requested that her heart be returned to the village she loved and where she spent some of her happiest days. A casket in the shape of a heart was found in the church during renovations in 1837/8 and was reburied beneath the organ, where it remains to this day. The story goes that the inquisitive finders could not resist opening the casket and discovered that it contained dust. There was no inscription on it but a plaque recording the find states that Anne's uncle, Sir Philip Parker, was responsible for carrying out her wishes. This is almost certainly incorrect, as Parker owned Erwarton Hall much later and completely rebuilt it in 1575. If anyone buried her heart at Erwarton Church it was Sir Philip Calthorpe, though opinion is split as to whether the tale has any substance. Unlike her head, which was definitely separated from her living body by a single blow from a French swordsman at the Tower of London on 19 May 1536, there is no actual evidence that Anne Boleyn's heart was removed after her death. Nevertheless, the discovery of a casket adds a degree of provenance to the legend.

The present Erwarton Hall is a private home and is out of bounds to the public. The elaborate red-brick gatehouse, probably dating from the sixteenth century, still survives. Erwarton Church continues to welcome visitors but, of course, the fabled heart-shaped casket that draws many to the building remains tantalisingly out of reach and sight.

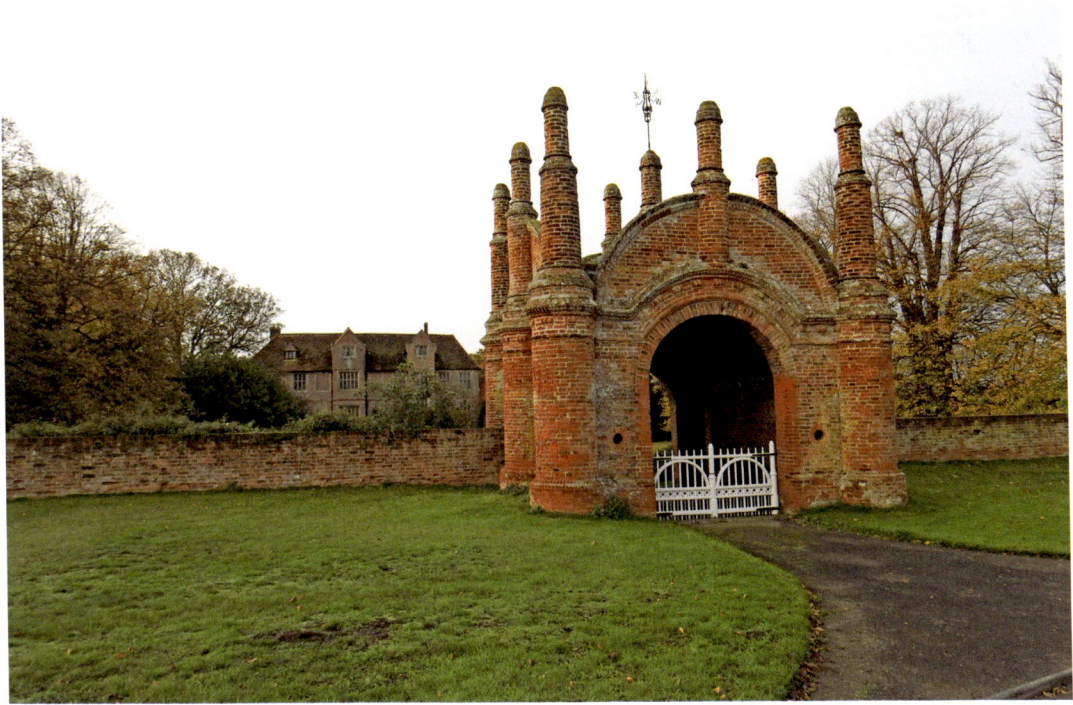

Erwarton Gatehouse and Hall. (© Adrian S Pye, CC-BY-SA/2.0, geograph.org.uk)

Mary Tudor, Queen of France

Another Suffolk church holds the remains of an earlier queen who was briefly the ill-fated Anne Boleyn's reluctant sister-in-law. Born on 18 March 1496 as the fifth child of Henry VII and Elizabeth of York, she was Henry VIII's sister, aunt of Mary I of England and Elizabeth I, and maternal grandmother of Lady Jane Grey.

On 9 October 1514, at the age of eighteen, Mary Tudor became the third wife of Louis XII of France. She was said at the time to be one of Europe's most beautiful and most graceful princesses. Her coronation took place on 5 November 1514 but the marriage was destined to be a short one. Louis XII died on 1 January 1515, possibly from gout, aged fifty-two. Mary then secretly married Charles Brandon, 1st Duke of Suffolk, in

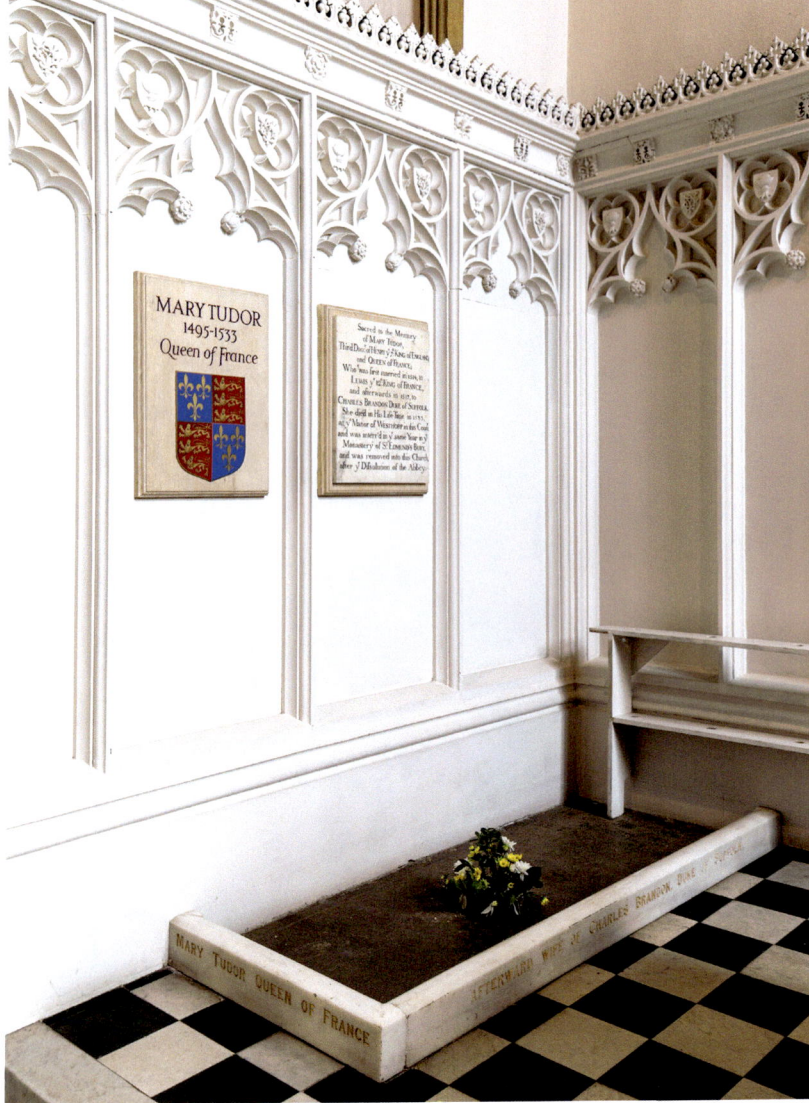

Tomb of Mary Tudor, 1495–1533, St Mary's Church, Bury St Edmunds. (© David P. Howard)

Paris on 3 March 1515. He had been sent to France by Henry VIII to bring Mary home, her brief tenure as Queen of France having come to an abrupt end. The King, who had intended that his widowed sister would marry another high-profile European royal, was not amused and regarded Brandon's actions as treason. When he calmed down, Henry agreed to attend an official marriage between Mary and Brandon at Greenwich Palace on 13 May 1515. However, he is said to have taken Mary's entire £200,000 dowry from her marriage to Louis XII, plus jewels and other expensive items that he had given her. In addition, Henry also presented the newly married couple with a massive fine of £24,000.

Although she was now the Duchess of Suffolk, for the remainder of her short life Mary Tudor was still known in England as Mary Queen of France. She and Brandon had four children together and lived at Westhorpe Hall (demolished in the late 1760s) near Stowmarket. Lady Frances, their eldest daughter, married Henry Grey, 3rd Marquess of Dorset. They were the parents of Lady Jane Grey, the 'Nine Days' Queen'. Mary was strongly against her brother's decision to divorce Catherine of Aragon and marry Anne Boleyn, but she died at Westhorpe Hall aged thirty-seven on 25 June 1533, a few weeks after Anne's coronation. She was buried at Bury St Edmunds Abbey on 21 July but, following the Dissolution, her remains were moved to St Mary's Church in Bury in 1538. Her grave was opened on 6 September 1784 and, bizarrely, locks of her hair were stolen by Horace Walpole – youngest son of Britain's first prime minister, Sir Robert Walpole – and other prominent individuals. A lock of Mary's hair is still preserved today at Moyse's Hall Museum in Bury St Edmunds.

Mary I of England versus Lady Jane Grey

Suffolk has strong connections with both of the protagonists in the battle for the English throne following the death of Edward VI. As stated above, Lady Jane Grey was the daughter of Lady Frances Grey (née Brandon) and her husband, Sir Thomas Grey, and granddaughter of Mary Tudor, Queen of France. Lady Jane married Lord Guildford Dudley, son of John Dudley, 1st Earl of Warwick and Duke of Northumberland, on 25 May 1553. Supported by her father-in-law, Lady Jane claimed the vacant throne on 10 July 1553, though it has been speculated that the teenager was bullied or coerced into taking on the dubious position. The Duke of Northumberland, a fearsome soldier and politician, was the power behind Edward VI, who was just nine years old when he was crowned on 20 February 1547. Northumberland and others are thought to have advised the ailing Protestant king that he should exclude his half-sister Mary from the line of succession as she was a Catholic. He was also persuaded to exclude his other half-sister, the future Queen Elizabeth I, despite her being a Protestant. Shortly before his death aged fifteen, Edward VI named Lady Jane Grey as his chosen successor.

Mary, the daughter of Henry VIII and his first wife, Catherine of Aragon, believed that she was the rightful heir to the throne. She ignored a summons to visit her dying sibling in London as it was almost certainly a trap to arrest and imprison her. Instead, she headed for East Anglia where she owned several properties. She wrote to the Privy Council from Kenninghall in Norfolk, outlining her claim to be recognised

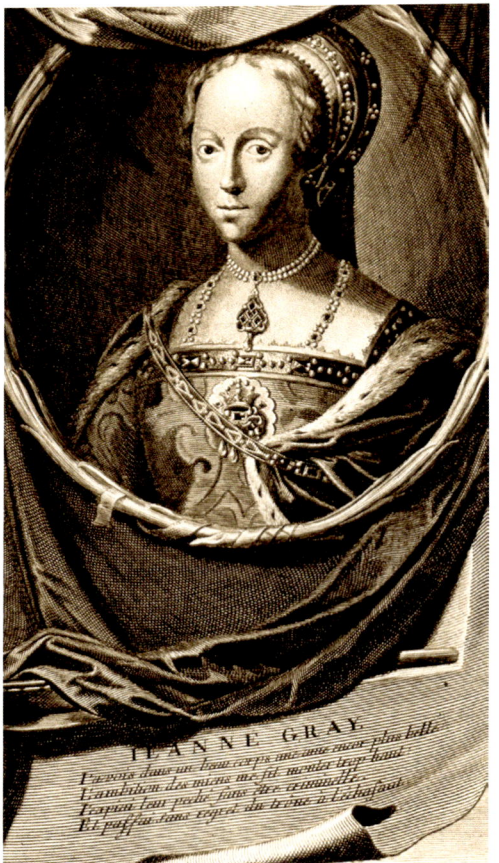 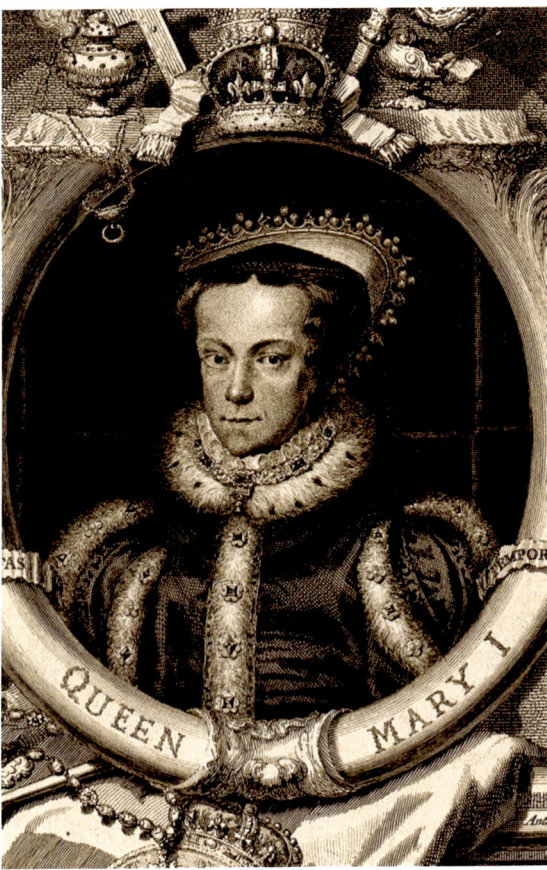

Above left: Lady Jane Grey. (Engraving by C. Vermeulen after A. Van Der Werff, *c*. 1730; Wellcome Collection, PDM 1.0)

Above right: Queen Mary I of England. (Engraving by G. Vertue, 1736, after H. Eworth; Wellcome Collection, PDM 1.0)

as the true Queen. Mary then went on to Framlingham Castle in Suffolk, which she had acquired in 1552. The Duke of Northumberland got wind of this and prepared to lead an army to attack the castle. He and his men left London and travelled north to Cambridge, arriving there by the evening of 15 July 1553. Northumberland was hated by many in East Anglia for his brutal suppression of the Norfolk Rising of 1549, which resulted in the executions of the Kett brothers and numerous others. Furthermore, they distrusted his motives for attempting to place his little-known daughter-in-law on the throne, which would effectively have made his son Guildford the King of England.

Meanwhile, support for Mary was growing in Suffolk and beyond. Sir Thomas Corn Wallis, the Sheriff of Norfolk and Suffolk, initially backed Lady Jane's claim to the throne but changed his mind after being confronted by Mary's supporters in Ipswich. He then

visited Mary at Framlingham Castle and pledged his allegiance to her. The Earl of Oxford also changed sides after his own men made their feelings clear.

Heavily armed warships anchored off the Suffolk coast were meant to provide firepower for Northumberland's army, but the crews of five of the six ships mutinied and hauled their heavy cannons inland to defend Framlingham Castle. Mary now had the guns and gunners she needed to repel an attack. On hearing the news, Northumberland realised he was outgunned and abandoned his plans. Support for Mary was also increasing in the capital and on 19 July 1553, the Privy Council reversed its earlier decision and agreed to Mary's demand to be proclaimed Queen of England. She learned of her accession when the Duke of Arundel and others arrived at Framlingham Castle on 20 July 1553 and begged her forgiveness. Other members of the Privy Council broke the news to the public at Cheapside and jubilant celebrations followed. Bonfires were lit and there was much dancing and singing in the streets of the capital.

Mary finally rode into London as the new monarch on 3 August 1553. Her entourage included her half-sister Elizabeth and over 800 supporters. She was crowned on 1 October at Westminster Abbey. Mary ordered the Duke of Arundel to arrest his former friend and ally the Duke of Northumberland, who was still in Cambridge. He was imprisoned and beheaded at Tower Hill in London on 22 August. His execution was watched by a crowd of around 10,000.

Lady Jane Grey, who spent her nine days as *de facto* Queen confined to the Tower of London, was informed by her father that she no longer held that title. Mary was originally inclined to spare Jane's life, but the teenager refused to renounce her Protestant faith and reportedly described the Catholic Mass as 'a form of satanic cannibalism'. Unsurprisingly, this did not please the new Queen and Jane was eventually beheaded by a single stroke of the axe at Tower Green on 12 February 1554, aged just sixteen or seventeen. Her husband, Guildford, was beheaded at Tower Hill earlier that day. Both are buried in the Chapel of St Peter ad Vincula. Sir Thomas Grey was beheaded on 23 February, due to his part in Sir Thomas Wyatt's plot to overthrow Mary when she became betrothed to Prince Philip of Spain. Lady Frances Grey, Duchess of Suffolk, was pardoned by Mary and lived at court until her death in 1559. She married Adrian Stokes, her Master of the Horse, in March 1555.

Like her aunt, Queen Mary of France, Mary I of England and Ireland is often known as Mary Tudor. She also acquired the nickname 'Bloody Mary' as she is said to have been responsible for the deaths of hundreds of Protestants during a short reign that ended with her death at the age of forty-two on 17 November 1558. Mary married Prince Philip of Spain at Winchester Cathedral on 25 July 1554, which made him the *jure uxoris* King of England and Ireland. They mainly lived apart and had no children together. Mary's half-sister, the staunchly Protestant Queen Elizabeth I, succeeded her and ruled England and Ireland for more than forty-four years.

Framlingham Castle has for many years been in the care of English Heritage and is open to the paying public. It has a long and eventful history, though is perhaps best known to a younger generation as local pop 'prince' Ed Sheeran's 'Castle on the Hill' (*see* chapter, 'Music Links and Inspirations').

Framlingham town sign. (© Adrian S Pye, CC-BY-SA/2.0, geograph.org.uk)

James II

The future King James II of England and Ireland and James VII of Scotland was no stranger to the coastal town of Southwold when he was Duke of York. An old plaque on the front of Sutherland House on the High Street records that this was his residence 'occasionally during the Dutch War 1665–1672'. A modern information board states that the Duke used it as his headquarters and 'stayed here frequently' between 1655 and 1674

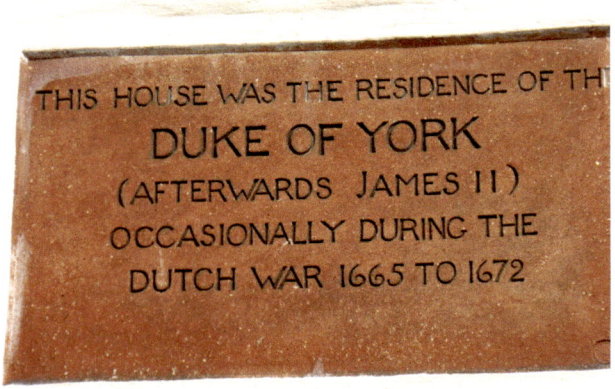

Plaque on Sutherland House, Southwold.

and 'directed his naval operations from here'. As Lord High Admiral of the Fleet, he led the allied ships against the Dutch fleet in the Battle of Sole Bay in 1672 (*see* chapter, 'Battles, Rebellions and Other Historical Happenings').

Ten years later, while still Duke of York, he almost drowned when his ship the *Gloucester* sank on the morning of 6 May 1682 after becoming beached on a sandbank. He and John Churchill, later to become the Duke of Marlborough, were rescued but up to 250 crew members and passengers died. The disaster was recorded by diarist Samuel Pepys, who was travelling with the royal fleet. On 10 June 2022, it was finally revealed that the wreck site had been found 28 miles (45 km) off the coast of Great Yarmouth fifteen years earlier. At the time of writing its exact location is still secret for security reasons.

If the Duke of York had gone down with his ship, he would never have acceded to the throne on the death of his elder brother, Charles II, on 6 February 1685. Consequently, the so-called 'Glorious Revolution' of 1688 would not have happened and the course of British history may have been very different. After being deposed from power, James II lived out his later years in France. Following his death at the Chateau de Saint-Germain-en-lage at the age of sixty-seven on 16 September 1701, Britain's last Catholic monarch was buried at the Church of the English Benedictines in Paris.

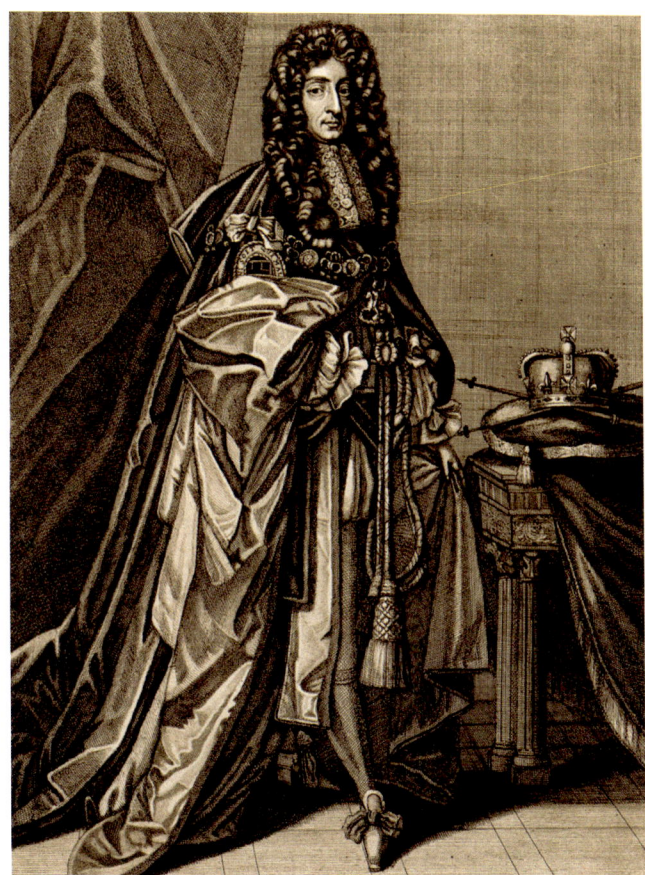

King James II. (Engraving by P. Landry, 1693; Wellcome Collection, PDM 1.0)

The Duleep Singh Family

After his enforced exile to Britain in 1852, Maharajah Duleep Singh took up residence at Elveden Hall in Suffolk in 1863. He and his first wife, Maharani Bamba Duleep Singh, raised their six children at Elveden Hall and two, the Princesses Catherine Hilda and Sophia Alexandra, were born there. Under the Maharajah's tenure the 17,000-acre Elveden estate became a game park complete with exotic animals, while the hall's interior was transformed with lavish Oriental-style furnishings. The Maharani passed away in London on 18 September 1887 at the age of thirty-nine. Duleep Singh attempted to return to India in 1886 but was stopped by the British authorities while in Aden. He lived out the rest of his life in Paris with second wife Ada Douglas Wetherill, and fathered two more children.

Following the Maharajah's death aged fifty-five on 22 October 1893, his body was returned to England and buried in Elveden churchyard alongside the graves of his first wife and young son, Prince Albert Edward Duleep Singh, who had died a few months before his father, aged just thirteen. Elveden Hall was then sold and since then has been owned by successive generations of the Guinness brewing family. Elveden Church and churchyard are accessible to the public but the hall and estate are not. The hall's interior is familiar to film fans as it has appeared in several blockbusters (*see* chapter, 'Film and Television Connections').

The Maharajah's eldest son, Prince Victor Albert Jay Duleep Singh (1866–1918), married Lady Anne Coventry in January 1898. Like several of his siblings he was a godchild of Queen Victoria. He too was prevented from visiting India but left England for good in

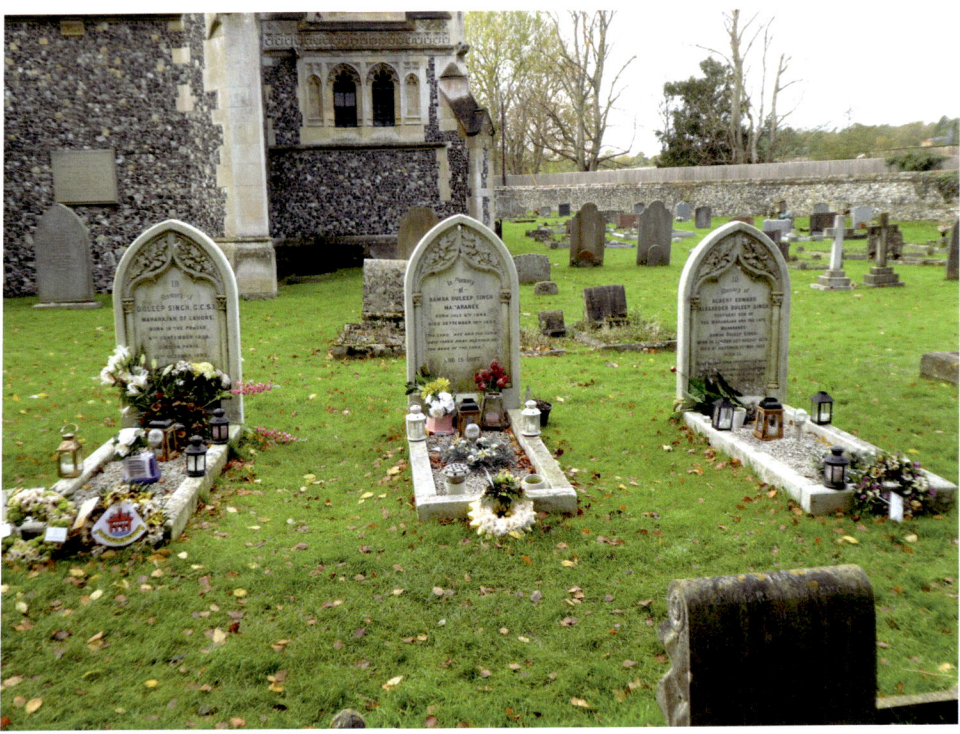

Duleep Singh family graves, Elveden churchyard.

1913 and spent the remainder of his relatively short life in France. Prince Victor and his widow, who passed away aged eighty-two in 1956, are buried side-by-side in the Anglican cemetery above Monte Carlo.

Duleep Singh's second son, Prince Frederick Victor Duleep Singh (1868–1926), was an army officer during the First World War and served with both the Suffolk and Norfolk Yeomanry. He died at Blo' Norton Hall, virtually on the border between Suffolk and Norfolk, where he had lived for the last twenty years of his life.

Princess Sophia Alexandra Duleep Singh (1876–1948) became a leading suffragette. Along with Emmeline Pankhurst and others, she was physically evicted from the House of Commons in 1910 while trying to speak with the Prime Minister. She sold *The Suffragette* magazine outside her apartment in Faraday House, Hampton Court, which was provided by her godmother, Queen Victoria, in 1898.

None of the Maharajah's eight children provided a legitimate heir to the royal Sikh dynasty.

Princess Caroline Murat

A quiet country churchyard in Suffolk is perhaps an unlikely place to stumble across a grand memorial to an American-born princess who was related to one of Europe's most famous historical characters. Caroline Laetitia Murat, the daughter of Prince Lucien Charles Joseph Napoleon Murat (3rd Prince Murat) and Caroline Georgine Frazer, was born in Bordentown, New Jersey, USA, on 31 December 1832 or 1833. She was a

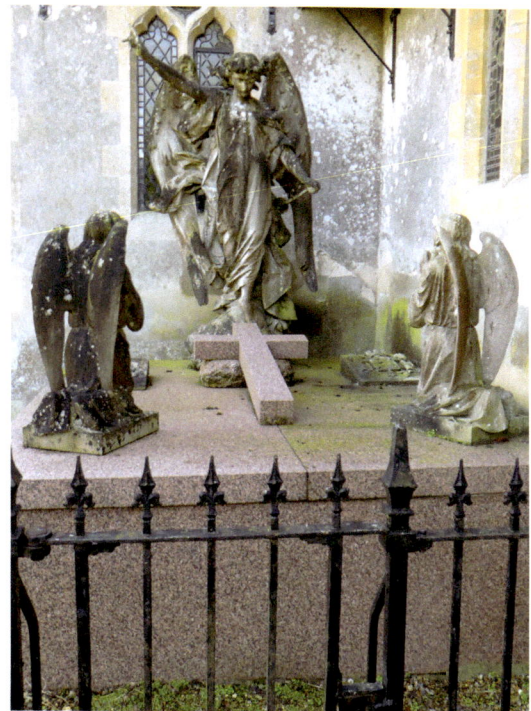

Left: Princess Caroline Murat's memorial, Ringsfield Church. *Right*: Ringsfield Church.

granddaughter of Joachim Murat, King of Naples, and Caroline Bonaparte Murat, sister of Napoleon Bonaparte.

After the death of her first husband, Baron Charles Martin de Chassiron, whom she wed in Paris in 1850, Princess Caroline married John Lewis Garden in 1872. He was the owner of Redisham Hall in Suffolk, where the couple resided for the remainder of their lives. After sampling the heady delights of Paris in her younger years, the princess is said to have initially found life in rural nineteenth-century Suffolk slow and uninspiring. She passed away at her home on 23 July 1902, ten years after Garden's death. They are buried at All Saints' Church, Ringsfield, near Beccles, where a large memorial monument featuring three angels was commissioned by their daughters.

Entrance to Redisham Hall. (© Geographer, CC-BY-SA/2.0)

2. Other Suffolk Historical Characters

Cardinal Thomas Wolsey

Born in Ipswich as the son of butcher Robert Wolsey and his wife Joan, Thomas Wolsey went on to become one of the most powerful men in England. His date of birth is unknown but it was probably around 1473–75. After attending Ipswich School he went on to Magdalen College School and was ordained as a priest on 10 March 1498. Wolsey's meteoric rise up the social standings really started in 1509 when Henry VIII gave him the position of almoner and a seat on the Privy Council. He was happy to take on many of the more mundane aspects of state, which suited the young monarch. As a result, Wolsey became one of the King's most trusted allies and was promoted to Archbishop of York in 1514. The following year he was made Lord High Chancellor of England.

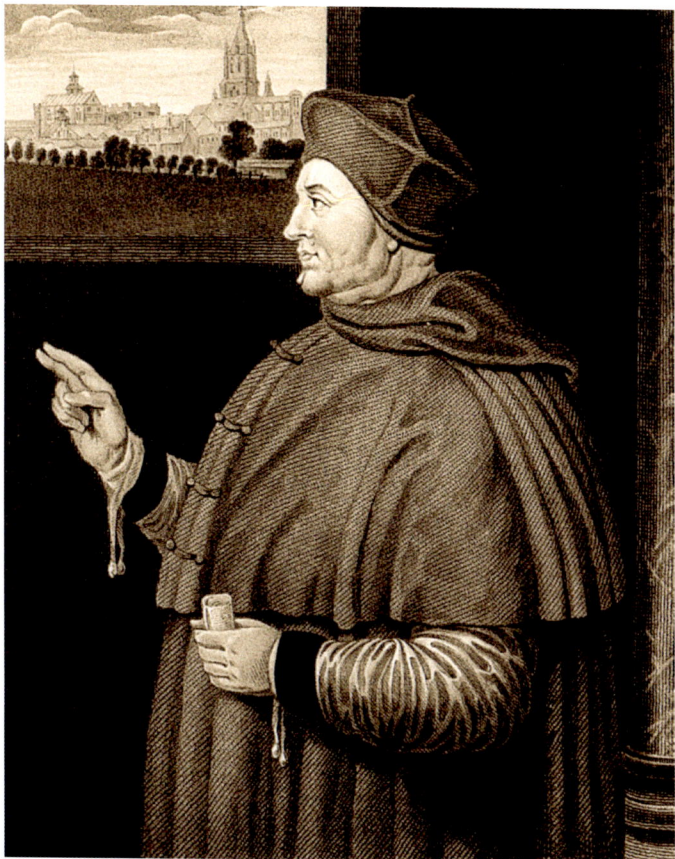

Cardinal Thomas Wolsey. (Wellcome Collection, CC BY-4.0)

Cardinal Wolsey's problems began when Henry VIII decided that his marriage to first wife Catherine of Aragon should be annulled so that he could marry Anne Boleyn. Her proposed marriages to her cousin James Butler, 9th Earl of Ormond in 1522, and Henry Percy, son of the 5th Earl of Northumberland in 1524, were both blocked by Wolsey. From early 1526, Henry VIII became increasing obsessed with Anne but, unlike her older sister Mary, she refused to become his mistress. When Wolsey failed to convince Pope Clement VII to agree to an annulment, the angry monarch relieved him of his title of Lord High Chancellor in 1529 but allowed him to continue as Archbishop of York. Most of his property was taken by the Crown and Henry moved into Wolsey's Hampden Court residence. While in North Yorkshire in 1530, he was ordered to return to London to answer accusations of treason. He only made it as far as Leicester, where he died on 29 November. Instead of the grand tomb that Wolsey had planned for himself at Windsor, he was hastily buried without fanfare at Leicester Abbey. No monument marked his grave but a statue of Wolsey now stands in Abbey Park, close to the abbey ruins.

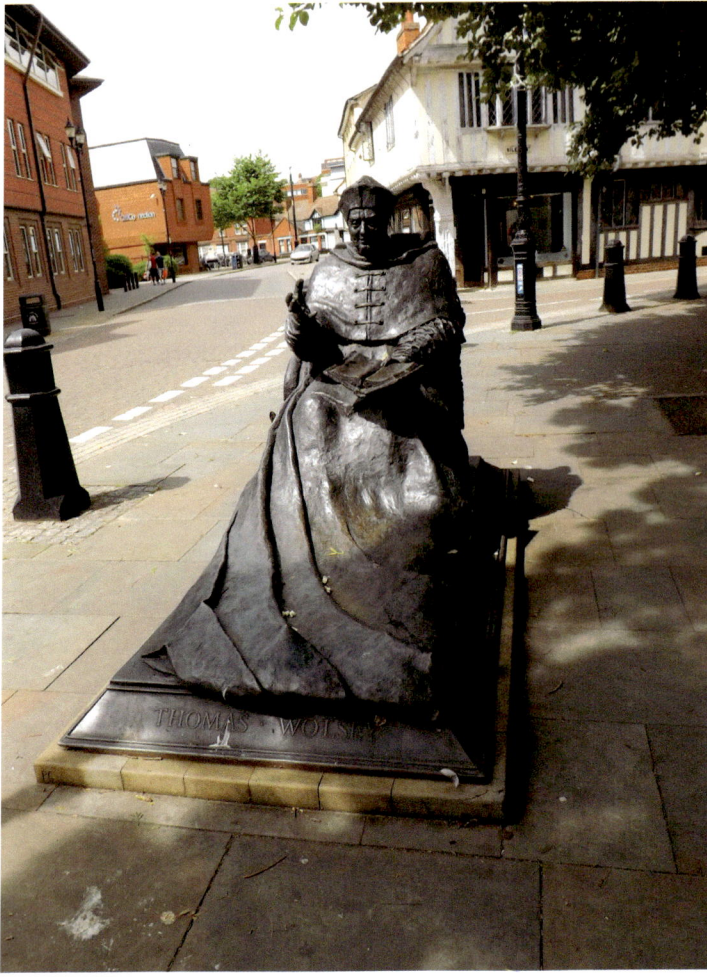

Statue of Thomas Wolsey, Ipswich. (© Geographer, CC-BY-SA/2.0, geograph.org.uk)

In his home town of Ipswich, a grand bronze statue was unveiled on St Peter's Street, close to the site of his childhood home, on 29 June 2011. The work of sculptor David Annand, it was dedicated by the Bishop of St Edmundsbury and Ipswich. Cardinal Wolsey is depicted larger than life-size in a seated position and reading from a book. There is also a bust of Wolsey in St Stephen's Church, Ipswich.

Thomas Gainsborough

Highly regarded artist Thomas Gainsborough was born in Sudbury in 1727. He was a child prodigy who was already a promising illustrator and painter at the age of ten. While still a teenager, he was commissioned to paint portraits of local luminaries including Lady Lloyd and her son Richard Savage Lloyd, of Hintlesham Hall near Ipswich. Gainsborough married the Duke of Beaufort's illegitimate daughter, Margaret Burr, in 1746. The couple moved from Sudbury to Ipswich with their two young daughters in 1752, before relocating to Bath seven years later and then to London in 1774.

The house where Thomas Gainsborough was born and grew up is named Gainsborough House and stands on Gainsborough Street in Sudbury. It was purchased by his parents in 1722 and was owned by the family until 1792. The property was converted to a guest house

Birthplace of Thomas Gainsborough, Sudbury. (© Roger Cornfoot, CC-BY-SA/2.0, geograph.org.uk)

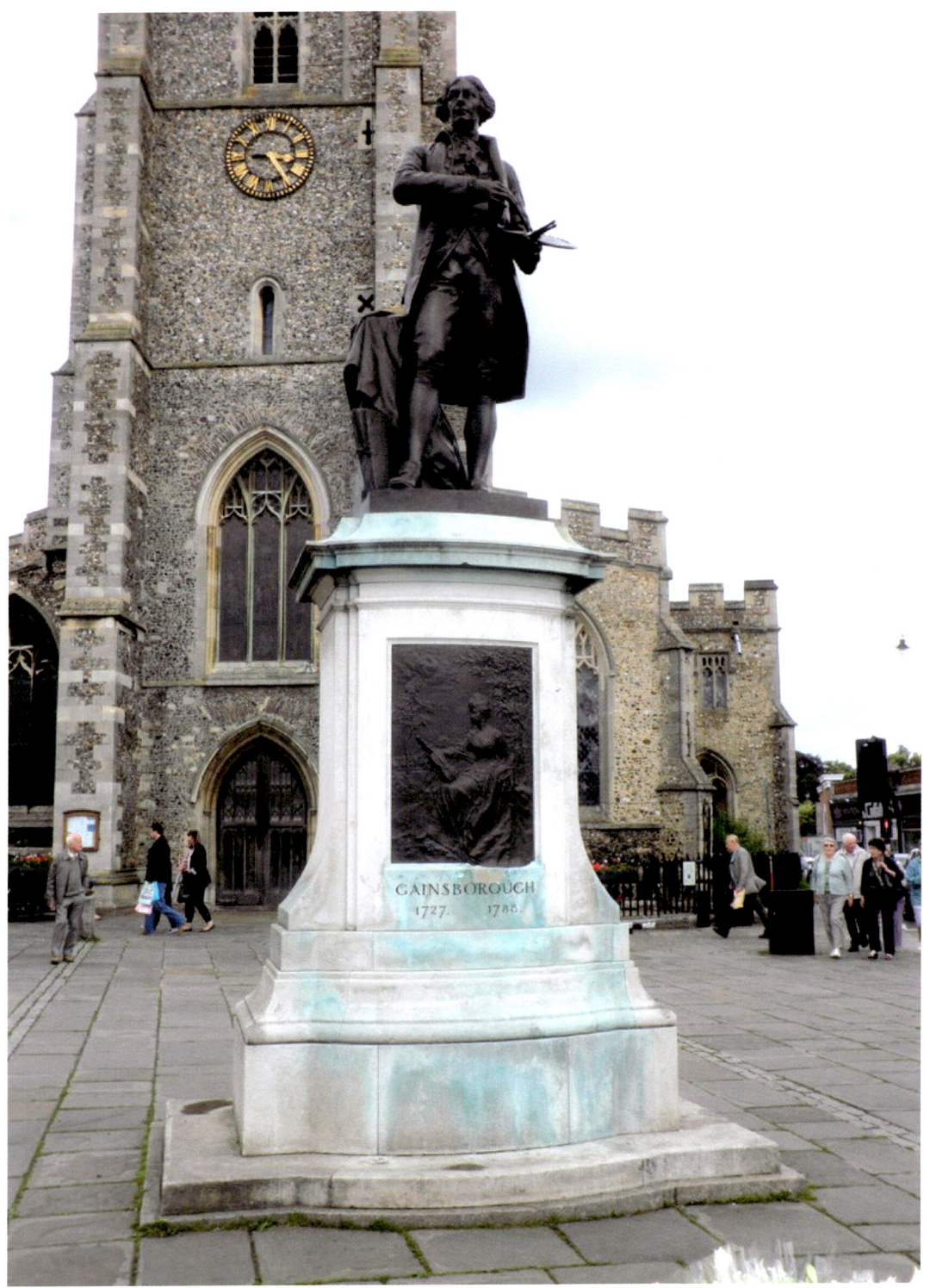
Statue of Thomas Gainsborough, Sudbury. (© Roger Cornfoot, CC-BY-SA/2.0, geograph.org.uk)

and tea rooms in the 1920s and later became an antiques shop. It was acquired in the late 1950s following support and donations from artists including Sir Alfred Munnings, and officially reopened as a museum in 1961. The house, associated cottages and gardens were renovated in 2005–7 at a cost of over £1 million. A bronze statue of Gainsborough was unveiled on Market Hill, Sudbury, by Queen Victoria's daughter Princess Louise on 10 June 1913.

Thomas Gainsborough died of cancer aged sixty-one in London on 2 August 1788. He is buried at St Anne's Church in Kew. Among his best-known works are *The Blue Boy*, *Mary and Margaret: The Painter's Daughters*, *The Morning Walk (Portrait of Mr and Mrs William Hallett)*, *Portrait of Mrs Graham*, *Girl with Pigs* and *Miss Read*. The latter painting was sold at auction by Christie's of London for £6.54 million in 2011.

John Constable

Another of Suffolk's – and Britain's – most renowned artists, John Constable, was born in East Bergholt on 11 June 1776. His corn merchant father, Golding Constable, owned Flatford Watermill, which would later be immortalised in several of the great painter's works. John Constable was educated at a boarding school in Lavenham and a day school in Dedham, just over the county boundary with Essex. On leaving school he too worked in the corn business, but was interested in art and the countryside from a young age and decided to become a full-time artist in 1799. He studied at the Royal Academy and was particularly inspired by Gainsborough and Rubens. He loved to paint the area around his home at East Bergholt and Flatford Mill in particular.

Constable's early works included *Boat Building near Flatford Mill* (1815), *Flatford Mill (Scene on a Navigable River)*, which was exhibited at the Royal Academy in 1817, and *The White Horse* (1819). His landscape paintings were often large-scale works known collectively as the 'six-footers'. These included *Stratford Mill* (1820), *The Hay Wain* (1821), *View on the Stour near Dedham* (1822), *The Lock* (1824) and *The Leaping Horse* (1825). *The Hay Wain*, now probably his most famous painting, did not sell when it was first exhibited, and was donated to the National Gallery by a collector in 1886. It was painted at Flatford Mill and features Willy Lott's Cottage – the home of local resident and tenant farmer William Lott (1761–1849) – which also appears in some of his other works.

John Constable married Maria Bicknell at St Martin-in-the-Fields, London, in October 1816. The couple had seven children before Maria died, aged forty-one, on 23 November 1828. Constable is said to have been in mourning for the remainder of his life, which came to a close due to heart failure on 31 March 1837. They are buried together in the churchyard of St John-at-Hampstead in London, along with their sons John Charles Constable and Charles Golding Constable.

Today, Flatford Mill and William Lott's former residence are run by the Field Studies Council for student courses and are not open to the general public. Both properties plus Bridge Cottage (seen in *Boys Fishing* (1813) and *View on the Stour*) and much of the surrounding area are owned by the National Trust. Now internationally famous as 'Constable Country', the locality is largely unspoilt but often very busy due to large numbers of visitors. St Mary's Church at East Bergholt appears in several of John Constable's pictures. It houses monuments to his wife Maria and her grandfather, the

Left: Interior of St Mary's Church, East Bergholt. *Right*: Bell Cage, St Mary's churchyard, East Bergholt.

Revd Dr Durand Rhudde (1734–1819), who was once rector there. Constable's parents are buried in the family tomb, which was last used in 1949. His father served as churchwarden for thirteen years and the family had their own pew in the centre aisle. William Lott's grave can also be seen in the churchyard. St Mary's has no tower but is famous for its sixteenth-century bell cage, which is claimed to house the heaviest set of working bells in England. Plans for a bell tower were abandoned after the death in 1530 of Suffolk-born Cardinal Wolsey, who had supported the project.

The sixteenth-century Grade I listed Christchurch Manor in Ipswich, now a free-to-enter museum, has the largest collection of original paintings by John Constable and Thomas Gainsborough outside of London.

Elizabeth Garrett Anderson

The second of eleven children, Elizabeth Garrett was born in London on 9 June 1836. Her father, Leiston-born Newson Garrett (1812–93), left Suffolk for the capital after leaving school. In 1841, he returned to Suffolk with his wife Louisa and their expanding young family. They lived near St Peter and St Paul's Church in Aldeburgh and Newson purchased a business in Snape, around 6 miles inland. He built Snape Maltings, now famous as

Elizabeth Garrett Anderson. (Wellcome Collection, PDM 1.0)

the home of the Aldeburgh Festival. He proved to be a successful businessman and the Garretts were able to move to a large new property named Alde House on the outskirts of Aldeburgh in 1852.

Elizabeth Garrett was home educated by her mother and, later, a live-in governess before she and her older sister attended the Boarding School for Ladies in Blackheath, London, from 1849 till 1851. She was inspired by Elizabeth Blackwell, the first female doctor in the United States, and met her when she visited Britain in 1859. Garrett became a surgery nurse at Middlesex Hospital the following year and managed to gain access to the Society of Apothecaries in 1862. She became the first female to officially qualify as a physician in Britain in 1865, but encountered gender discrimination and was unable to find a hospital that would employ her in that role. As a result, she was forced to go it alone and opened her own private medical practice in London later that year. In 1866, she set up St Mary's Dispensary for Women and Children, which in 1872 changed its name

to the New Hospital for Women and Children. The East London Hospital for Children employed her as a visiting physician between 1866 and 1873, making her the first woman in the country to be assigned a medical post. Also in 1866, she became the first female to be elected to a British school board.

Elizabeth Garrett married James Anderson in 1871 and took his surname but, unusually at that time, also retained her own maiden name. She gave birth to two girls and a boy between 1873 and 1877 but her second daughter died of meningitis in 1875. As Dr Elizabeth Garrett Anderson she became a member of the British Medical Association (BMA) in 1873, but between 1878 and 1892 women were banned from admittance to the organisation. Remarkably, Garrett Anderson became president of the BMA's East Anglian branch in 1897. She co-founded the London School of Medicine for Women in 1874 and was its dean from 1883 until she retired in 1902. This made her the first female dean of a British medical school.

In addition to being a pioneering physician and surgeon, Garrett Anderson was also a campaigner for women's rights – not least the entitlement to vote – and was a member of various women's suffrage groups. Her sister, Millicent Garrett Fawcett (1847–1928), was also a campaigner for equality, as was Elizabeth's daughter Louisa (1873–1943), who also qualified as a doctor. Louisa was jailed in 1912 for her increasingly militant involvement with the suffrage movement.

After the death of her mother in 1903, Elizabeth and her husband, who passed away in 1907, moved into Alde House. Elizabeth followed in her father's footsteps as mayor of

St Peter and St Paul's Church, Aldeburgh. (© Geographer, CC-BY-SA/2.0, geograph.org.uk)

Aldeburgh in 1908, claiming yet another first as no woman in England had previously been elected to such an office.

Elizabeth Garrett Anderson continued to live at Alde House until her death, aged eighty-one, on 17 December 1917. Her name lives on in Suffolk with the Garrett Anderson Centre at Ipswich Hospital. The New Hospital for Women which she founded in London became the Elizabeth Garrett Anderson Hospital in 1918. The building is now occupied by the trade union UNISON. The University College Hospital (UCH) has a wing named after the pioneering doctor. She lies in the churchyard of St Peter and St Paul's in Aldeburgh and a memorial to her parents can be seen inside the church. Other notable former residents buried there include Benjamin Britten, Peter Pears and Imogen Holst.

Alfred Munnings

Artist Alfred Munnings was born on 8 October 1878 in the Mill House at Mendham Watermill, where his father was the miller. The landscape by the River Waveney at Mendham inspired several of his paintings including *The Path to the Orchard* and *Stranded*. He was educated at Framlingham College and began an apprenticeship aged fourteen with a printing firm in Norwich. He designed and illustrated advertising posters for them and also attended the Norwich School of Art before becoming a full-time painter in 1898. An accident in that year left him blind in one eye but he quickly gained a reputation as a talented artist.

Munnings was associated with the Newlyn School, based on the south coast of Cornwall, from 1912 to 1914. He moved to Castle House in Dedham, just over the county

Mendham village sign.

border in Essex, in 1919, and married Violet, his second wife, the following year. His first wife, Florence, tragically died aged twenty-six in 1914. Although he continued to paint the countryside and portraits of society figures of the day, Munnings became most famous for his paintings of horses. He was president of the Royal Academy of Arts from 1944 until his death and was a fierce critic of such artists as Picasso, Matisse and Cézanne. He was knighted in the 1940s and three volumes of his autobiography were published between 1950 and 1952.

Alfred Munnings died aged eighty at his home in Dedham on 17 July 1959. His ashes were buried in St Paul's Cathedral. Since the early 1960s, Castle House has been used as the Munnings Art Museum and attracts many visitors. His birthplace still exists and is part of the private Mendham Mill estate which is not generally open to the public. It is, however, one of several properties on the site that are available for lease as holiday accommodation. The mill itself stopped work in 1932 and was converted into a residence by then owner Grace Philcox. Munnings is remembered in Mendham with a pub and a road named after him. The village sign depicts a local woman named Charlotte Gray leading a pony by the River Waveney. She was featured in one of the artist's paintings and is buried in Mendham churchyard.

Munnings' oil painting *The Red Mare* (1923) sold for $7,848,000 at auction in 2007. Some of his other works have also sold for seven-figure sums. Actor Dominic Cooper played Munnings in the 2013 film *Summer in February*.

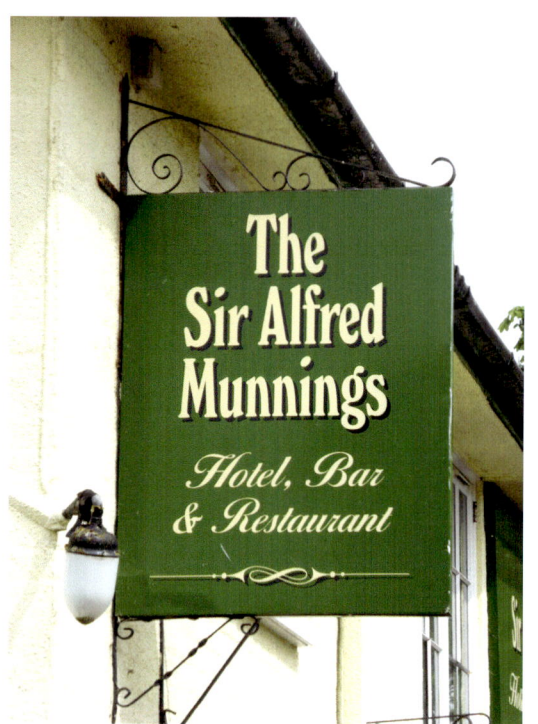
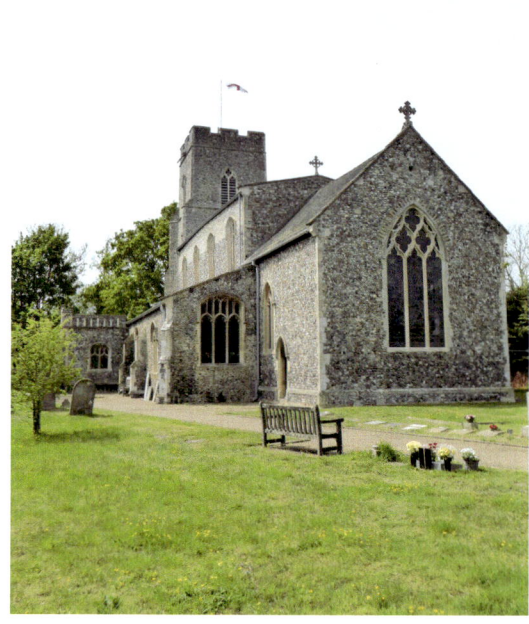

Left: The Sir Alfred Munnings sign, Mendham. *Right*: All Saints' Church, Mendham.

3. Battles, Rebellions and Other Historical Happenings

Simon Sudbury and the Peasants' Revolt

The unrest and violence known as the Peasants' Revolt affected many parts of the country in 1381 and Suffolk was no exception. Poor working people gathered together to demand higher wages and lower taxes, a recurrent theme that echoes down the centuries. At the same time, the Black Death and famine tore through the population and together all of these factors resulted in a mass uprising that spread like wildfire across the land. Although most of the rebels were men, a number of women also took up arms and some were local leaders.

Probably the most high-profile casualty of the Peasants' Revolt was the incumbent Archbishop of Canterbury, himself a Suffolk man born in Sudbury around the year 1316. Simon Theobald, son of Nigel and Sara Theobald, is generally known as Simon of Sudbury or simply Simon Sudbury. He was educated in Paris and Rome before being appointed Bishop of London in 1361 and Archbishop of Canterbury in May 1375. In addition to this role he became Lord Chancellor of England in January 1380, and introduced a highly unpopular form of poll tax payable by everyone over the age of fifteen. During rioting by protesters on 14 June 1381, he and Sir Robert Hales, the Lord High Treasurer, were dragged from St John's Chapel in the Tower of London during Mass and violently murdered. It is said to have been the only time in the Tower's long history that its defences were breached, though it appears that the guards were sympathetic to the rebels' cause and allowed them entrance. According to a much later account of events, Sudbury's head was finally separated from his body after eight blows from a sword or axe. His body was buried in a grand tomb in Canterbury Cathedral, but after being exhibited on a pole on London Bridge his head was returned to his home town. It still resides in a compartment in the vestry wall of St Gregory's Church in Sudbury. To add insult to injury, his teeth were removed and sold as relics. A likeness of the ill-fated Archbishop went on display in the church on 15 September 2011, following forensic examination of his skull.

The rebels who killed Simon Sudbury had set out from Canterbury a few days earlier. One of their leaders was Wat Tyler, who met the fourteen-year-old Richard II at Smithfield on 14 June to voice his grievances and demands. He suffered a similar fate to Simon Sudbury the following day, being publically beheaded after apparently attempting to stab the Lord Mayor of London in the King's presence. His head was also fixed to a pole and displayed on London Bridge. A number of other rebels were later arrested and executed, some beheaded in Sudbury outside St Gregory's Church. According to some sources it was a woman named Johanna Ferrour who helped capture Simon Sudbury and Sir Robert Hales and ordered their beheadings. She was named in court documents as 'chief perpetrator and leader of rebellious evildoers from Kent', but her fate is unclear.

The Murder of Simon Sudbury at the Tower of London in 1381. (Coloured lithograph, 1845; Wellcome Collection, PDM 1.0)

Meanwhile, back in Suffolk, a renegade clergyman named John Wrawe was starting to organise local men to take up arms against the establishment. He may have been born in Pentlow near Sudbury, virtually on the border between Suffolk and Essex. Some accounts describe him as either a serving or former chaplain from Sudbury, while others state that he was a parson at Ringsfield Church near Beccles. There is some disagreement among historians as to whether these descriptions refer to the same person or two separate individuals. It is likely that Wrawe knew Wat Tyler and John Ball, another leader and

radical former priest who was executed on 15 July 1381. On 12 June 1381, Wrawe, along with other leaders and supporters, ransacked and destroyed a manor house at Liston belonging to Sir Richard Lyons, a wine merchant and former Sheriff of London. The rebels apparently paid particular attention to disposing of taxation documents and liberating the contents of his wine cellar! Lyons was at his London home at the time but was killed by Wat Tyler – a former servant to Sir Richard – two days later.

The following day, rebels attacked and demolished Pentlow Hall, the property of Sir John Cavendish who was the Chief Justice of England and Chancellor of the University of Cambridge. He was later captured and beheaded on a bank of the River Brandon as he tried to escape by boat. The rebels marched on to Bury St Edmunds, where they destroyed Cavendish's town house and stormed Bury Abbey. In the absence of an abbot at that time, the Deputy Prior, John Cambridge, was in temporary charge but he was warned of the approaching danger and fled the town with another monk, John Lakenheath. They were tracked down on Mildenhall Heath and beheaded. Their heads, along with those of Sir John Cavendish and others, were impaled on spikes in the market place. The Abbey was ransacked and the town was under the rebels' control for just over a week. After Wrawe turned down the title of 'King of Suffolk', a deputy called Robert Westbrom (or Westbroun) was given the dubious honour. Wrawe and 500 others attacked Mettingham Castle near Bungay on 18 June, and again caused much damage. It was owned by the de Norwich family, who the rebels regarded as traitors.

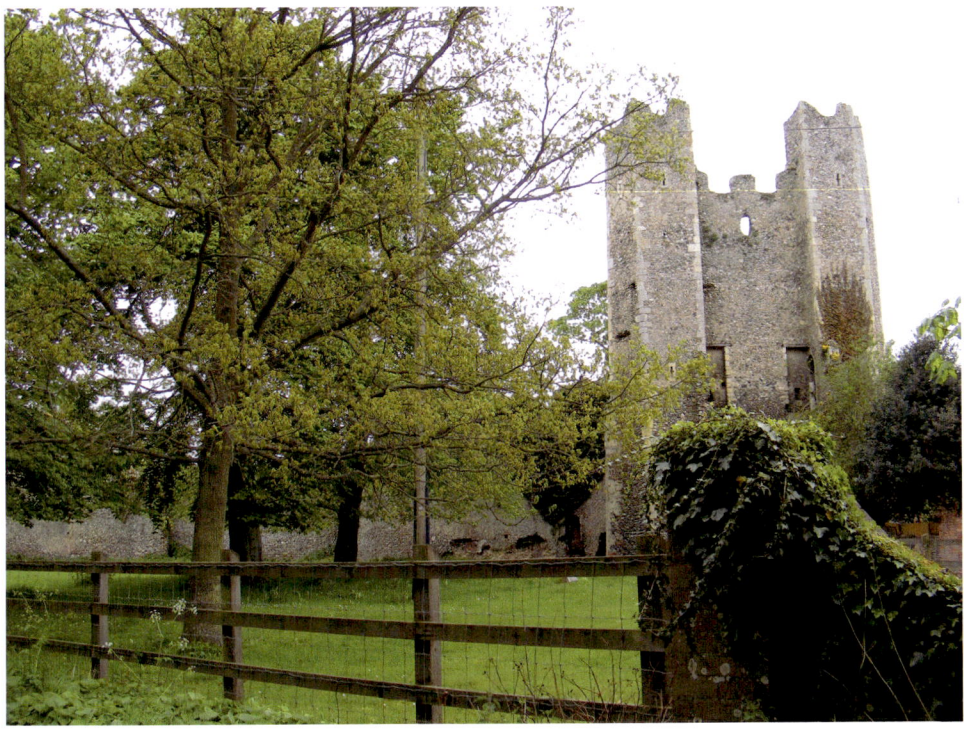

Mettingham Castle ruins. (© Geographer, CC-BY-SA/2.0, geograph.org.uk)

Wrawe's reign of terror ended on 23 June 1381, when a formidable army regained control of Bury St Edmunds with little further bloodshed. According to conflicting sources, it was led either by William Ufford, Earl of Suffolk, or Henry le Despenser, Bishop of Norwich, who led a crusade to Flanders in 1383 and was known as the 'Fighting Bishop'. This effectively ended the revolt in Suffolk and le Despenser crushed resistance in neighbouring Norfolk at the Battle of North Walsham on 25 or 26 June. In Bury, the rebels were deserted by their leader, who was captured and put on trial in London. Despite turning King's evidence and implicating many of his followers, John Wrawe was hanged, drawn and quartered on 6 May 1382.

The events of 1381 in Bury St Edmunds followed serious unrest and violence there earlier that century. A rebellion in January 1327 saw the Abbey's defences breached by up to 3,000 townsfolk, who burst through the gates and caused much damage. In October of that year, armed monks attacked the townsfolk, who fought back and almost destroyed the Abbey. When the authorities finally regained control several months later, many of the town's citizens were hanged or imprisoned. It was partly this simmering resentment between the Abbey and the townsfolk that finally boiled over fifty-four years later. The ruins of Bury Abbey, finally demolished during the Disillusion of the Monasteries, can be seen alongside the present St Edmundsbury Cathedral. The remains of Mettingham Castle also still exist off Castle Road, Mettingham, but are privately owned and not open to the public.

The Bigod Barons of Bungay and the Great Fire

The small market town of Bungay, close to Suffolk's boundary with Norfolk, has seen more than its share of tumultuous history. In medieval times the castle was an important stronghold of generations of a formidable family which frequently clashed with the monarchy and controlled areas of Suffolk, Norfolk and Essex. In addition, a devastating fire in the seventeenth century almost wiped Bungay from the map, and events during a frightening storm a century earlier gave rise to one of Suffolk's most famous legends.

The first castle in Bungay was built by Roger Bigod (c. 1060–1107), one of William the Conqueror's Normandy barons, around 1100. He was rewarded by William, who bestowed on him many estates and manors across East Anglia. Roger Bigod is buried in Norwich Cathedral. His son, the much-feared Hugh Bigod, 1st Earl of Norfolk (1095–1177), assembled a powerful army and attacked Norwich Castle in 1136 during the reign of King Stephen. Bigod surrendered after Stephen's forces laid siege to the city. After Henry II came to the throne in 1154, he confiscated Hugh Bigod's castles in Bungay and Framlingham but returned them to him in 1164. Bigod started building a heavily fortified new stone castle to house his private army in Bungay in 1165, which may have taken almost a decade to complete. The walls were between 16 ½ and 23 feet (5–7 metres) thick and the keep was around 110 feet (33.5 metres) tall. Bigod clashed with the King again in 1173–74, when in collaboration with the Earl of Leicester he took Haughley Castle near Stowmarket but failed to capture Norwich and Dunwich. Henry II's army marched into Suffolk and Bigod surrendered to the King at Syleham. Though he retained the title of Earl of Norfolk, his private army was disbanded and his castles at Bungay

Above and below: Ruins of Bigod's Castle, Bungay.

and Framlingham were ordered to be destroyed. An unrepentant Hugh Bigod voiced his defiance in a short verse:

> Were I in my Castle of Bungay
> Upon the River Waveney,
> I would not give a button
> For the King of Cockney

A mining gallery, which still exists, was dug beneath Bungay Castle with the intention of setting fire to the foundations. Some accounts state that the castle was indeed destroyed but others suggest that it may have been spared after the wealthy Hugh paid Henry II the sum of 1,000 marks. Hugh Bigod is believed to have died in Palestine during a crusade, by which time he would have been in his eighties. His son Roger, 2nd Earl of Norfolk (c. 1144/1150–1221), inherited his estates, which were returned to the family by Richard I around 1178. The 2nd Earl, supported by his son Hugh (c. 1182–1225, later 3rd Earl), was one of twenty-five barons who banded together to force King John to sign Magna Carta at Runnymede on 19 June 1215, but John retaliated by temporarily seizing Bigod's castle at Framlingham the following year.

To confuse matters further, the 4th and 5th Earls were both named Roger. The 4th Earl (c. 1209–70), who had previously been an ally of Henry III, led a band of barons and knights on London in 1258 and succeeded in demanding constitutional changes. The 5th Earl (c. 1245–1306), the last of the Bigod barons, rebuilt Bungay Castle in 1294–7, including the twin gateway towers and curtain walls which still survive today. He was probably the first Bigod to live in Bungay since the death of Hugh, the 1st Earl, the others residing at Framlingham. Like his predecessors, he too had disagreements with the reigning monarch, in this case Edward I. He famously refused the King's command to fight in Gascony, France, in 1297, and lived to tell the tale. After he died childless his castles and other estates became the property of the Crown.

By 1382, Bungay Castle was already derelict. Much of its stonework was plundered and recycled locally to build houses in the fifteenth century. An illustration dated 1819 shows a narrow four-storey house nestling between the gate towers. Little remains of the once mighty keep. Victorian enthusiasts removed accumulated rubble from the site and extensive repairs were carried out during the 1930s. The Duke of Norfolk presented Bungay Castle to the town in 1987. The ruined fortress is now in the care of Bungay Castle Trust and for a small fee can be entered via 'Bigod's Kitchen' during normal opening hours. The castle inspired a novel by local writer Elizabeth Bonhôte (see 'Literary Locations and Inspirations').

The conflagration that destroyed most of the centre of Bungay on 1 March 1688 was one of the worst in Suffolk's history. For this reason there is little evidence of medieval architecture in the town centre today. Homes, shops, two market crosses and the Grammar School were either completely obliterated or seriously damaged. Around 200 families suddenly became homeless and many sought refuge in St Mary's Church, which was also severely affected. The south aisle and tower were fire damaged and the church bells are said to have melted. The interior suffered the effects of the fire, not helped by the

townsfolk bringing what remained of their charred and still-burning possessions with them. St Mary's did not reopen as a place of worship until 1701, following the installation of a new south aisle roof and a new altarpiece. It is now redundant but is open to the public. The churchyard holds the ruins of St Mary's Priory, which is said to have been founded around 1160 by Hugh Bigod's wife Gundreda, who later married Sir Roger de Glanville. Holy Trinity Church, situated a short distance from St Mary's, escaped damage and a plaque on the door states, 'Here was the Fire stayed, 1688'.

Such was the extent of the devastation that a national appeal was launched to help citizens who had lost their homes and livelihoods to the flames. Thanks to generous donations much of the town centre was rebuilt within a relatively short time span. The impressive Butter Cross was built in 1689 and the Statue of Justice which tops the lead-domed roof was added in 1754. Much of present-day Bungay dates from the Georgian period and beyond, when it became a thriving community.

The great thunderstorm that hit Bungay on 4 August 1577 was said to be like no other seen before or since. Two men in the belfry of St Mary's were killed by lightning and some parishioners gathered for Sunday service were either killed or injured. This true event spawned the Black Dog of Bungay legend, which has been fully embraced by the town and is retold in full in my book *Illustrated Tales of Suffolk* (Amberley Publishing, 2020).

The Priory Church of St Mary, Bungay.

The Battle of Sole Bay

The Battle of Sole Bay, also called the Battle of Southwold, was fought off the Suffolk coast in 1672. This marked the start of the third Anglo-Dutch War, which lasted until 1674. The first and second wars took place between 1652–54 and 1665–67, respectively. A fourth conflict erupted in 1780 and lasted for four years. The wars were mainly fought over trade and colonisation.

On the early morning of 7 June 1672 (Gregorian calendar; 28 May on the Julian calendar), a fleet of British warships was anchored off Southwold for refitting prior to a planned joint British and French attack on the Netherlands. Many sailors were onshore, some no doubt feeling the effects of a night's delights in the town's drinking houses, when a French frigate arrived at 2.30 a.m. and brought the shocking news that a large Dutch fleet had been spotted heading towards the Suffolk coast. The crewmen that had retired for the night were rudely awakened and the English ships were ready to sail at 5.30 a.m. The English fleet was commanded by James, Duke of York (the future King James II) and Lord High Admiral of the Fleet, who was staying at Sutherland House in Southwold. A French fleet was anchored off Dunwich but instead of joining the British contingent they fired long-range salvos from what might be regarded as a safe distance. It has been speculated that this was either a navigational error or a deliberate strategy by the French to let the English and Dutch fleets destroy each other. Nevertheless, French casualties during the battle reportedly numbered around 450 men.

Sutherland House, Southwold.

The Duke of York was aboard the HMS *Royal Prince* and Admiral Edward Montague, 1st Earl of Sandwich, was on the HMS *Royal James*. Forty-six-year-old Montague was also staying at Sutherland House and according to local gossip was late arriving at his ship after spending his last night with a sixteen-year-old serving maid. After the *Royal James* was attacked by Dutch fire ships, Montague drowned while trying to escape the sinking vessel and his body was washed up further along the coast a week later. It is said that, just before setting sail, he told a friend that he would 'see him no more'. Montague's body was identified only by the Order of the Garter shield on his uniform. Some claim that the heartbroken serving maid's spirit still waits for Edward Montague in a bedroom of Sutherland House.

Although the Duke of York survived uninjured, he had to change ship on two occasions, finally finishing the battle on HMS *London* after the *Royal Prince* and *St Michael* were put out of action by the Dutch. The battle was fought around 10 miles out to sea and continued until around 7 p.m. Onlookers along the cliffs in Southwold struggled to make out which side had the upper hand but could hear the incessant sound of the guns. Nobody was allowed to leave the town that day in case they were needed to help repel a possible Dutch land assault. According to various sources, the combined English and French fleets numbered around ninety–ninety-eight ships, up to 35,000 men and 5,500–6,000 guns.

The Southwold cannons.

The Dutch had around seventy–seventy-five ships, 21,000 men and 4,500 guns. The English lost at least 2,000 men and the Dutch around 1,800. Numerous dead bodies were washed up along the Suffolk coast and 800 wounded sailors were brought ashore in Southwold. The original account of the Battle of Sole Bay was written at Sutherland House by the Duke of York's secretary Matthew Wren, a cousin of Sir Christopher Wren. Both main protagonists claimed the battle as a victory for their side, but in truth there was no obvious winner. The English and Dutch fleets would meet again the following year at the Battle of Schooneveld.

Six cannons were presented to Southwold in 1745 to help protect against possible future conflict, though they were never used in anger. They still stand on Gun Hill looking out to sea and were last fired in 1842 to mark the birthday of the Prince of Wales. A gunner, thirty-year-old James Martin, was horribly killed when a cannon exploded just as he was inspecting the barrel. Unsurprisingly, it is rumoured that his headless ghost occasionally revisits Gun Hill. Sutherland House still exists on the High Street, having survived Southwold's catastrophic fire of 1659, and is a hotel and restaurant. Dating from 1445, it was once the home of Thomas Cammel, an Elizabethan merchant. A building further along the High Street is named Montague House and was once the home of author George Orwell (*see* chapter, 'Literary Locations and Inspirations').

The Battle of Fornham

The Battle of Fornham was the culmination of a dispute over Henry II's decision to award lands to his youngest son, Prince (later King) John. Henry's three other legitimate sons rebelled against their father and joined the court of King Louis VII of France. Robert de Beaumont, the 3rd Earl of Leicester, landed at Walton in Suffolk in late September or early October 1173, accompanied by thousands of Flemish mercenaries. He and his army then approached Bury St Edmunds, apparently with the intention of ransacking Bury Abbey, which was one of England's richest monasteries. They were intercepted by forces loyal to Henry II while attempting to cross the River Lark and a fierce confrontation ensued.

The Battle of Fornham took place on 17 October 1173, during which Leicester's cavalry was captured and the Flemish mercenaries were forced into a swamp where most of them were slaughtered. It is estimated that around 3,000 mercenaries lost their lives that day, many reportedly killed by 'local peasants'. The King's supporters, commanded by Richard de Lucy (or de Luci) and consisting of more than 300 knights plus additional militia provided by the earls of Arundel, Cornwall and Gloucester, were greatly outnumbered but proved to be a far superior fighting force. The Earl of Leicester was captured along with his wife, Petronilla de Grandmesnil, who was wearing armour. Leicester was imprisoned until January 1177, when some of his former properties were given back to him. In the interim, several of his castles had been destroyed and those that remained had been taken by the King.

Today there are three villages in the area which carry the name Fornham: Fornham St Martin, where the battle is reputed to have begun; Fornham St Genevieve, where it possibly ended; and Fornham All Saints. At least forty skeletons were found near Fornham St Genevieve Church in 1826, several of which had wounds which appeared to have been sustained during violent conflict. They were 'discovered in a heap, piled in

Fornham St Martin cum Fornham St Genevieve village sign. (© Adrian S Pye, CC-BY-SA/2.0, geograph.org.uk)

order, tier above tier, with faces upward and feet towards centre'. Swords, daggers, knives and rings were later retrieved while draining land close to the River Lark. The ruins of Fornham St Genevieve Church still exist, while the village sign at Fornham All Saints commemorates the battle. At the time of writing, the Fornham 2023 Project is planning a number of events leading up to and coinciding with the 850th anniversary of the battle. It is intended that the site receives greater recognition in line with its historical importance.

There may be a possible connection between the events at Fornham and the legendary Green Children of Woolpit. An apparently orphaned boy and girl with green-tinged skin,

who spoke a language that nobody could understand, were supposedly found in a pit in the village during the late twelfth century. The boy died but the girl survived and later claimed that they came from St Martin's Land, which some believe could be Fornham St Martin.

The Hadleigh Gang and Other Suffolk Smugglers

A notorious gang based in Hadleigh controlled much of the smuggling that went on along the Suffolk coastline during the eighteenth century. With 100 members and access to 200 horses, the Hadleigh Gang caused major problems for the law enforcement agencies. In contrast to the romantic notion of smugglers as Robin Hood-like characters peacefully redistributing goods to the needy, they were a well-organised and ruthless group not averse to eliminating those who stood in their way.

The gang's leader was John Harvey, who owned Pond Hall in Hadleigh. It still exists, as does the George Inn which also has strong connections with the gang. Goods were brought ashore at several places including Sizewell Gap near Leiston, which was an isolated location where the smugglers could operate largely unseen. The Vulcan Arms at Sizewell was an important base. Exactly how the gang managed to transport the contraband over 35 miles inland to Hadleigh is unclear, but they probably had a string of safe houses along the route. They definitely had a base at Semer, north-west of Hadleigh, which was raided by customs men with military back-up in 1735. The recovered booty was taken to

St Mary's Church, Hadleigh.

the George Inn for overnight storage, but around twenty members of the Hadleigh Gang burst in and fought a battle with the authorities. The gang successfully retook the hoard but one dragoon was shot dead and several more were injured. Seventeen smugglers were identified and two were hanged for firing pistols. John Harvey was still leader in 1747, when he was sent to Newgate Prison and later sentenced to seven years' transportation. In his absence, the gang continued to wreak havoc and managed to liberate confiscated goods stored at the King's Warehouse in Ipswich.

For many years there have been rumours of secret tunnels beneath Hadleigh, either linked with smuggling or other activities. One tunnel said to be three-quarters of a mile long supposedly linked St Mary's Church and the adjacent Deanery with a monastery or nunnery on Lady Lane. Other tunnels allegedly existed beneath The George Inn and Pond Hall, though there is little evidence to support this.

Many other locations across Suffolk were smuggling hotspots, though space allows mention of just a few. At Woodbridge, which is famous for its still-operational Tide Mill, a cutter being used by smugglers ran aground in 1739 and its cargo of brandy and tea was seized by the authorities. Illicit deliveries often found their way to Ipswich, while the Ship Inn at Levington, 6 miles south-east of Ipswich, and The Butt and Oyster Inn at Pin

The historic Woodbridge Tide Mill.

Mill, also had smuggling connections. John Key, once the landlord of the Queen's Head at Blyford, later moved to Beccles. At both locations his smuggling activities brought him into conflict with customs officers, but he is said to have disappeared for good after being attacked in Beccles by other smugglers in 1745. Key lived in the aptly named Smugglers' Lane (now Wash Lane) in Beccles. Aldeburgh and various locations on the River Alde were also 'free trading' hotspots. One particularly notorious smuggler was Richard Chaplin, from Sudbourne near Aldeburgh, who announced his 'retirement' from the trade in the local press!

Stranded boats at low tide in Woodbridge.

4. Literary Locations and Inspirations

Charles Dickens: Pickwick and Copperfield

The great novelist Charles Dickens (1812–70) is known to have visited Suffolk on several occasions. He stayed at the Angel Hotel, Bury St Edmunds, in 1835, 1859 and 1861, and his book *The Pickwick Papers* was partly written there. In the story, Mr Pickwick is very uncomplimentary in his opinion of the Great White Horse Hotel in Ipswich, which is presumably based on the author's own experiences. Dickens's account of a corrupt election in the fictitious Eatanswill may be based on one he reported on in Sudbury in 1835. A giant blue plaque recording his visits is attached to an exterior wall of the Angel Hotel, while the room he stayed in is now called the Charles Dickens Suite.

During a visit to Great Yarmouth in January 1849, when he stayed at the Royal Hotel, Dickens walked to Lowestoft and back. Whilst walking he saw a road sign for the village of Blundeston, which he used (as Blunderstone) for the birthplace of the title character in *David Copperfield*. The story was serialised between May 1849 and November 1850 and published as a complete book in 1850. It is rumoured that Dickens made a detour to

Left: Blundeston village sign. *Right*: St Mary's Church, Blundeston.

Blundeston, though there is no firm evidence that he actually went there. Nevertheless, David is featured along with St Mary's Church – also mentioned in the book – on the village sign. There is also a Dickens Court in Blundeston. A story that Dickens called at Somerleyton Hall, located to the west of Blundeston, is also uncertain. Television and film adaptations of *David Copperfield* have been partly filmed in Suffolk (*see* chapter, 'Film and Television Connections').

Suffolk was part of the itinerary for Dickens's famous literary tours, where he gave public readings of his works. On one such occasion he is believed to have stayed overnight at Bungay's allegedly much-haunted Three Tuns Inn, where more than a century earlier the notorious highwayman Dick Turpin may also have rested for the night.

George Orwell: The Suffolk Sojourns

One of the twentieth century's most famous and influential authors, George Orwell (25 June 1903-21 January 1950), is best remembered for his last two books, *Animal Farm* (1945) and *Nineteen Eighty-Four* (1949). The completion of his final work, which gave the world such terms as 'Big Brother', 'Room 101' and 'Thought Police', became a race against time before Orwell's early death at the age of forty-six.

George Orwell Press photo, 1943. (Branch of the National Union of Journalists)

Eric Arthur Blair was born in Motihari, Bengal Presidency, British India. His pen name was inspired by Saint George and the River Orwell which flows through Suffolk. The Blair family moved to Stradbroke Road, Southwold, in 1921, when Eric's father retired, and later lived in Montague House on the High Street. After spending time at Craighurst in Southwold cramming for an exam to enable him to join the Imperial Police, Orwell served with them in Burma. He later moved to Paris for nearly two years before returning to Southwold in 1929, where he wrote some of his early works. He worked as a teacher at The Hawthorns High School for boys in Hayes, West London, for a while in 1932 and at Fray's College, Uxbridge, the following year. After being hospitalised due to pneumonia, he went home to Southwold to recuperate in January 1934.

Orwell's first book, *Down and Out in Paris and London*, was based on his own experiences and published in 1933. It was followed by the novels *Burmese Days* (1934), which was completed in Southwold, and *A Clergyman's Daughter* (1935), which was written there between January and September 1934. It told the story of Dorothy Hare and her struggle with amnesia. The main character was inspired by Brenda Salkeld, a gymnastics teacher at St Felix Girls' School in Southwold and a vicar's daughter. Orwell repeatedly asked her to marry him but without success.

Montague House, Southwold.

In the book, 'Ye Olde Tea Shoppe' mirrored a similar business run by his sister Avril. Southwold was thinly disguised as Knype Hill, and the socialist author's scathing views regarding the town's upper-middle-class demographic were laid bare. Many of the locals disliked the dishevelled writer and regarded him as a troublemaker and womaniser with little chance of achieving anything. After finishing the book, which is regarded as a precursor to *Nineteen Eighty-Four*, Orwell moved to London and did not return to live in Southwold. The character of Julia in his final masterpiece was supposedly based on a Southwold neighbour and friend named Eleanor Jacques. Montague House has a plaque on the front stating that this was Orwell's family home from 1932 to 1941. It was unveiled by Richard Blair, the author's adopted son, on 20 May 2018. Also in Southwold, an impressive mural of Orwell can be seen on the Pier Cafe.

During his time in Suffolk, Orwell reported a strange occurrence while relaxing in St Andrew's churchyard, Walberswick, on 27 July 1931. The present church partially nestles within the ruined walls of its much larger predecessor. Orwell claimed to have witnessed an apparition of a 'small and stooping' figure which passed through an archway and suddenly vanished. Others have also spoken of similar encounters there.

St Andrew's Church, Walberswick.

George Crabbe: Suffolk's 'Forgotten' Poet

Although not widely read today, the work of Suffolk poet George Crabbe was appreciated by the likes of Byron, Tennyson, Jane Austen and Walter Scott. Crabbe was born in Aldeburgh on Christmas Eve 1754. He was educated at boarding schools in Bungay and Stowmarket before becoming a surgeon's apprentice at the age of fourteen. From 1768 to 1771 he was based at Wickhambrook, near Bury St Edmunds, and then moved to a new employer at Woodbridge until 1775. He returned to Aldeburgh but decided to move to London in late 1779. There Crabbe approached statesman and author Edmund Burke, who helped him find a publisher and also recommended him for ordination as a curate.

Portrait of George Crabbe. (The poetical works of the Revd George Crabbe ... by his son; Wellcome Collection, PDM 1.0)

On 21 December 1781, George Crabbe was appointed curate at Aldeburgh but his return to his home town was not a happy one. His mother had died and his father had turned to alcohol, and Crabbe felt that he was not welcome there in his new role. Again with assistance from Edmund Burke, he left Aldeburgh once more the following year to take up a new position as chaplain to the Duke of Rutland at Belvoir Castle in Leicestershire.

In December 1783, George Crabbe married Sarah Elmy, whom he met during his time in Woodbridge. Sarah's mother lived in Beccles and the couple's wedding took place at St Michael's Church, which is unusual in being one of only two Suffolk churches to have a detached bell tower. Thirty-four years earlier, Revd Edmund Nelson and Catherine Suckling – parents of Horatio Nelson – were married in the same church.

George Crabbe and his new wife lived at Belvoir Castle until 1785, when he accepted a vacant position as curate at Stathern in Leicestershire. They went on to have seven children, though only two survived beyond childhood. Crabbe started writing in the 1770s and self-published a poem called *Inebriety* in 1775. Six years later *The Library* was published, followed in 1783 by *The Village*, which was at least partly about Aldeburgh. It is considered to be one of his best poems but the follow-up, *The Newspaper* (1785),

St Michael's Church and Bell Tower, Beccles.

was inferior and was the last poem he published until 1807. A collection simply titled *Poems* included previously published work and a mammoth new piece called *The Parish Register*, based on an actual register of births, deaths and marriages which ran to more than 2,000 lines. *The Borough* (1810) was another very long piece in twenty-four parts and one section inspired composer Benjamin Britten to write his opera *Peter Grimes* (*see* chapter, 'Twentieth Century Personalities'). The opera's title character was based on a shady individual from Aldeburgh, a fisherman whose young apprentices all lost their lives in his employ. *The Borough* was followed by *Tales in Verse* (1812), *Tales of the Hall* (1819) and *Posthumous Tales* (1834). Many of Crabbe's poems dealt with the bleak realities of life and were based on his own experiences. Their themes, often combined with great length and complexity, set them apart from the output of the popular Romantic poets of the day.

George Crabbe is said to have been addicted to opium for much of his life but did not suffer the ill effects often associated with its prolonged use. He eventually became a wealthy man from the sales of his work and retired from the clergy. He died aged seventy-seven in Trowbridge on 3 February 1832, nineteen years after the death of his wife Sarah.

Thomas Nashe: Controversial Playwright and 'Obscene' Poet?

Thomas Nashe, an Elizabethan poet, playwright, satirist and pamphleteer, was born and baptised in Lowestoft in 1567, when his father, William Nashe, was a curate there. The family moved to West Harling rectory near Thetford in 1573/74, but Thomas and his older brother Israel were the only two out of seven siblings to reach adulthood. Thomas was educated at St John's College, Cambridge, from around 1581 until 1588 and gained a bachelor's degree in 1586. Nashe later relocated to London, where he became embroiled in several controversies. His best-known works include the books *Terrors of the Night* and *The Unfortunate Traveller* (both 1594), the popular pamphlet *Pierce Penniless* (1592) and the play *Summer's Last Will and Testament*, first performed in 1592 and published in 1600.

In the early 1590s, Nashe wrote a long and explicit erotic poem called *The Choise of Valentines*, which was denounced by some as being 'obscene'. The poem describes in detail the sexual union between 'Tomalin' and his lover, 'Mistris Francis', in the brothel where she works. Nashe made powerful enemies in London due to satirical works such as *Christ's Tears over Jerusalem* (1593) – which resulted in a short stay in Newgate Prison – and *Have with You to Saffron Walden* (1596). A comedy play he wrote with Ben Jonson called *The Isle of Dogs* (1597) proved to be the last straw. Jonson was jailed and Nashe fled the capital. He relocated to Great Yarmouth and penned another satire titled *Nashe's Lenten Stuffe* (1599), about the town's great herring industry.

This was to be his last published work and he is thought to have died around two years later. His place of death and burial are not recorded. It has been speculated that Nashe and Christopher Marlowe may have collaborated with William Shakespeare on the bard's *Henry VI, Part 1* (1591), though this is unproven. Similarities between part of *A Midsummer Night's Dream* (Act 5) and a short extract from Nashe's *Terrors of the Night* have also been noted.

Lowestoft town sign.

The Strickland Family of Authors

The prolific Strickland family have been compared by some to another, more famous writing dynasty, the Brontës. Thomas Strickland and his wife Elizabeth moved from Surrey to Thorpe Hamlet near Norwich, before relocating to Stowe House on Flixton Road, Bungay, in 1802. In 1808, the family moved again to Reydon Hall near Southwold. After Thomas Strickland died in 1818, several of the couple's daughters took to writing as a means of income.

Renowned historical author Agnes Strickland (1796–1874) was originally a poet and her early work includes *Worcester Field*, *The Seven Ages of Woman* and *Demetrius*. She wrote a mammoth twelve-volume set titled *Lives of the Queens of England* (published 1840–48) and a number of other biographies including *The Letters of Mary Queen of Scots* (1842–43) and *Lives of the Tudor Princesses, including Lady Jane Grey and her Sisters* (1868). She also produced many books for children between 1822 and 1841. Agnes Strickland never married and died at Park Lane Cottage, Southwold. She is buried in the churchyard of St Edmund's in the centre of the seaside town. Reydon Hall, which was sold in 1864 following the death of her mother, still exists as a private residence.

Reydon Hall. (© Adrian S Pye, CC-BY-SA/2.0, geograph.org.uk)

St Edmund's Church, Southwold.

Catharine Strickland (1802–99) began publishing books anonymously at the age of sixteen and went on to amass a large collection of work spanning various genres. Soon after her marriage to Lieutenant Thomas Traill in 1832, the newlyweds emigrated to Canada. Now writing as Catharine Parr Traill, she documented life as a European settler in the fledgling colony. She had a keen interest in the area's natural history and became a knowledgeable amateur botanist. Her many books include *The Backwoods of Canada* (1836), the novel *Canadian Crusoes* (1852) and *The Female Emigrant's Guide* (1854). She died in Lakefield, Ontario, at the age of ninety-seven.

Susanna Strickland (1803–85) was born at Stowe House, Bungay, and became a well-known author under her married name, Susanna Moodie. She and her husband, John Moodie, also left England for Canada in 1832, along with Thomas and Catharine Traill. Like Catharine, Susanna wrote about life in the Canadian wilderness in several books including *Roughing it in the Bush* (1852) and a sequel, *Life in the Backwoods* (1853). She started her literary career as a children's writer in 1822 with *Sparticus*. Susanna also produced a poetry book titled *Patriotic Songs* (1830) in collaboration with her sister Agnes, and five novels between 1853 and 1868.

Samuel Strickland (1804–67), who was also born in Bungay, was the first of the siblings to emigrate to Canada in 1825/26. He put down roots in the Lakefield area and although

not primarily a writer, penned *Twenty-seven years in Canada West* and *The Experience of an Early Settler*. Like his sisters Catharine and Susanna, he is better known in Canada than in Britain and is regarded as one of the country's true pioneers.

Jane Margaret Strickland (1800–88) remained in Suffolk and died in Southwold. Less well known than some of her siblings, she published several books including *Adonijah: A Tale of the Jewish Dispersion* in 1856 and *The Life of Agnes Strickland* in 1887.

Although never actually credited as an author, Elizabeth Strickland (1794–1875) is known to have been a co-writer and researcher on many of her sisters' books, particularly the major historical works by Agnes Strickland. Elizabeth apparently rejected the offer of joint author status as she wished to remain anonymous.

Henry Rider Haggard and Other Bungay Connections

Best-selling novelist Sir Henry Rider Haggard (1856–1925) lived and wrote at Ditchingham House, just over the county border in Norfolk, and is buried at Ditchingham Church. He was also a familiar face in Suffolk and presented a seventeenth-century Flemish carving titled *The Resurrection* to St Mary's Church in Bungay. Rider Haggard, whose books include *King Solomon's Mines* and *She*, also had a holiday residence called Kessingland Grange near Lowestoft. It was here that his youngest daughter, author Lilias Rider Haggard, claimed a sighting of the legendary Kessingland Sea Serpent in 1912.

Bungay Castle, the best-known work by author and poet Elizabeth Bonhôte (née Mapes), was first published in 1796. The Gothic novel was inspired by the impressive landmark in

Bungay town centre.

the centre of the market town where she was born in a house close to the King's Head in April 1744, to baker and grocer James Mapes and his wife Elizabeth. The writer married Bungay solicitor Daniel Bonhôte on 13 October 1772, and they had three children. Daniel became Under-Sheriff of Suffolk and owner of Bungay Castle, which he acquired in 1791. Already a romantic ruin by that time, it fired Elizabeth's imagination and led her to write her most successful book. The Bonhôtes later moved to Bury St Edmunds, where Daniel died in 1804. Elizabeth passed away in Bungay on 11 June 1818, aged seventy-four. *Bungay Castle* was last republished in 2006. Elizabeth Bonhôte Close keeps the author's name alive in her home town.

Other literary figures connected with Bungay include Margaret Barber (1869–1901), who wrote a successful book of meditations called *The Roadmender* published after her early death, and novelist Elizabeth Jane Howard, who died aged ninety at her Bungay home in 2014. Children's writer and illustrator James Mayhew and novelist Louis de Berniéres live in or near Bungay.

J. M. Barrie: *Peter Pan* and Thorpeness

Famous Scottish writer J. M. Barrie (9 May 1860–19 June 1937) was a frequent visitor to the holiday village of Thorpeness, created by Glencairn Stuart Ogilvie in the 1910s and 1920s. Barrie was a friend of Ogilvie's and remains best known for his character Peter Pan. The shallow boating lake known as the Meare was inspired by Barrie's work and includes miniature islands, Crocodile's Lake, Pirate's Lair and Wendy's House. A footpath around the Meare is called Barrie's Walk.

The Meare, Thorpeness.

Thorpeness is a unique seaside village that has been dubbed 'Neverland' and 'The Home of Peter Pan'. It vies with Port Merion in Wales for the unofficial title of Britain's strangest village. Thorpeness is also famous for its amazing 'House in the Clouds', a former water tower and now a high-rise holiday home. It was given its name by children's author Mrs Malcolm Mason, who lived in the tower beneath its enormous water tank during the 1920s.

P. D. James: Adam Dalgliesh and Other Stories

Phyllis Dorothy James (3 August 1920–27 November 2014) had a holiday hideaway in Southwold and used the county's towns and villages as locations in a number of her best-selling books. Southwold has a leading role in her dystopian novel *The Children of Men*, published in 1992 and set in England in the year 2021. The main premise is that 'no child has been born for twenty-five years' and 'the human race faces extinction'.

P. D. James' most famous character is Adam Dalgliesh, a police detective who rises through the ranks. In *Unnatural Causes* (1967) he takes a holiday on Monksmere Head, south of Dunwich, in his aunt's cottage. Dalgliesh also visits the imposing Holy Trinity

Holy Trinity Church, Blythburgh.

Church, Blythburgh, nicknamed the 'Cathedral of the Marshes', which is also mentioned in James' autobiography published in 1999. Covehithe Church near Southwold features in *Death in Holy Orders* (2001), which like many of her books has been adapted for television (*see* chapter, 'Film and Television Connections').

P. D. James was appointed an OBE in 1983 and became Baroness James of Holland Park in 1991. She continued writing in her later years and died at the age of ninety-four.

Ruth Rendell: Suffolk Inspirations

Another famous author, Ruth Rendell (17 February 1930–2 May 2015), was born in South Woodford, Essex, and lived in various parts of Suffolk including Aldeburgh, Sudbury and Polstead. The latter location is still famous for the notorious 'Red Barn' murder of Maria Marten by William Corder in 1827. The village gets a mention in Rendell's psychological thriller *A Fatal Inversion*, published in 1987 and set in 1976 during that year's blisteringly hot summer. It also features Nayland and a fictional Suffolk mansion named Wyvis Hall.

The novel *Gallowglass* (1990) is set in Sudbury, and *No Night Is Too Long* (1994) includes references to Aldeburgh and Orford. *The Brimstone Wedding* (1995) is located in and around Bury St Edmunds. All of the above were published under the pen name Barbara Vine. An earlier Rendell novel, *Make Death Love Me* (1979), is one of her grittiest and opens with an armed robbery at the Anglia Victoria Bank in the fictional Suffolk town of Childon. She also wrote a non-fiction book titled *Ruth Rendell's Suffolk* in 1989.

One of Polstead's ponds.

Like P. D. James, Rendell created a famous fictional detective, Chief Inspector Wexford, who appeared in twenty-four of her books between 1964 and 2013.

Ruth Rendell was made a Life Peer in 1997 with the title of Baroness Rendell of Babergh, CBE. She is buried at St Bartholomew's Church in Groton, situated between Hadleigh and Sudbury.

W. G. Sebald in Suffolk

German author W. G. (Winfried Georg) Sebald (18 May 1944–14 December 2001), who preferred to be known as Max, visited a number of Suffolk places for his acclaimed book *The Rings of Saturn*. First published in German in 1995 and in English three years later, it blends fact, fiction and mythology, and records the author's thoughts and meditations during a walking tour of coastal Suffolk which he began in August 1992. Dunwich, Southwold and Covehithe feature prominently in the book and Sebald describes 'the earth's slow turning into the dark' as he 'sat there in Southwold overlooking the German Ocean'. In addition to ruminating on the mysterious celestial phenomenon which inspired the book's title, he examines the work of seventeenth-century Norwich-based physician, writer and philosopher Sir Thomas Browne.

W. G. Sebald was closely associated with the University of East Anglia (UEA), both as a lecturer (from 1970) and as a chair of European literature (from 1987). He died of a heart attack aged fifty-seven while driving in Norfolk, where he lived for many years.

Leper Chapel ruins, St James' churchyard, Dunwich.

His daughter Anna, who was a passenger in the car, survived the ensuing collision with an oncoming lorry. Sebald is regarded by many as one of the most gifted authors of his generation. He is buried in a modest grave at St Andrew's churchyard in Framingham Earl, near Norwich. Director Grant Gee's 2012 film *Patience (After Sebald)* is based on *The Rings of Saturn*.

The Suffolk coast also features in *Morke over Dunwich* (Darkness over Dunwich) by Norwegian science-fiction and fantasy author Øyvind Myhre, which is set in a strange alternative version of the village. Published in 1991, it is heavily influenced by the work of American horror, science-fiction and fantasy author H. P. Lovecraft (1890–1937).

Other Literary Connections

The 1938 murder mystery *Blind Man's Hood* by American author John Dickson Carr (writing as Carter Dickson) was loosely based on the Suffolk killing of a pregnant twenty-three-year-old maid servant. In the book, a couple visit a friend's seemingly empty house on Christmas Eve and encounter a mysterious young woman who tells them about an unsolved murder there many years earlier. In reality, Rose Harsent was stabbed to death at Providence House in Peasenhall where she lived and worked, on 1 June 1902.

St Michael's Church, Peasenhall.

Rose Harsent's grave, Peasenhall cemetery.

The prime suspect was tried twice but on both occasions the juries failed to reach a unanimous verdict and he walked free. In a slightly surreal twist, the prosecutor was Henry Fielding Dickens, son of author Charles Dickens. Peasenhall is an attractive village with St Michael's Church at its heart. Miss Harsent's grave is in the local cemetery, a short walk from the church.

While training to become a teacher during the First World War, children's author Enid Blyton (11 August 1897–28 November 1968) stayed with friends George and Emily Hunt at Seckford Hall, Great Bealings, near Woodbridge. The property, which had secret passageways and was claimed to be haunted, is believed to have influenced some of her stories. The hall was converted to a country house hotel in the 1950s and is still used for that purpose. Blyton began a teacher training course at Ipswich High School in September 1916. A very prolific writer, her best-known characters include the Famous Five, the Secret Seven and Noddy.

Another prominent children's author, Arthur Ransome (1884–1967), lived in Suffolk for several years. His book, *We Didn't Mean to Go to Sea* (1937), was part of the *Swallows and Amazons* series and was partly set on the River Orwell. It chronicles the misadventures of a group of children who accidentally drift out to sea in their boat *Goblin*, modelled on Ransome's own vessel *Nancy Blackett*. This is still in running order and is available to hire from Woolverstone Marina near Ipswich.

5. Twentieth-century Personalities

Suffolk has links with many well-known people who were born and first came to prominence during the twentieth century, from politicians and inventors to stars of stage and screen. Some are featured below, along with local places with which they are associated. Other famous celebrities, including present-day actors and music stars, are mentioned in later chapters.

Benjamin Britten

Classical composer Benjamin Britten was born at 21 Kirkley Cliff Road, Lowestoft, on 22 November 1913. His childhood home is now the Britten House Hotel and a plaque in his memory adorns the gateway of the building. After attending South Lodge School in his home town, he was a border at Gresham's School in Holt, Norfolk, from 1928 to 1930. Between 1930 and 1933, he studied at the Royal College of Music in London. Britten

Britten House Hotel, Lowestoft.

bought the Old Mill in Snape for £450 in 1937 and converted it to residential use. Apart from time spent in America between 1939 and 1942, it was his home until 1947 and his property until 1955. It is now used for self-catering holiday accommodation.

After reading the works of Aldeburgh poet George Crabbe, Britten was inspired to write his acclaimed opera *Peter Grimes*, based on part of Crabbe's epic narrative poem *The Borough*. It was written at the Old Mill and first performed at Sadler's Wells in London on 7 June 1945. The leading roles were taken by Britten's partner, the operatic tenor Peter Pears, and soprano Joan Cross, who was the company's artistic director. *The Young Person's Guide to the Orchestra* was written in 1945 and premiered the following year. His next opera, *The Rape of Lucretia*, was also premiered in 1946. Britten co-founded the famous Aldeburgh Festival in 1948 (*see* chapter, 'Music Links and Inspirations').

Benjamin Britten received a life peerage and the title of Baron Britten of Aldeburgh in June 1976. He died of congestive heart failure aged sixty-three on 4 December 1976. A memorial service attended by Queen Elizabeth the Queen Mother was held at Westminster Abbey on 10 March 1977. Britten and Peter Pears, who passed away aged seventy-five on 3 April 1986, are buried side by side in the churchyard of St Peter and St Paul's in Aldeburgh. A stained-glass window in the church commemorates Britten's life and work.

Britten and Pears lived at Crag House, Aldeburgh, from 1947 until 1957, when they purchased the Red House. Their remaining years were spent there and it was restored by

The Red House, Aldeburgh. (© Roger Cornfoot, CC-BY-SA/2.0, geograph.org.uk)

the Britten-Pears Foundation in 2013 at a cost of £4.7 million. Britten's own grand piano has pride of place in his studio on the first floor.

An imposing 13-foot (4-metre) tall stainless steel sculpture named *Scallop* was erected as a tribute to Britten in 2003 on Aldeburgh beach, where he used to walk daily. Words from *Peter Grimes* – 'I hear those voices that will not be drowned' – are inscribed around the edges of the shell. The sculpture was made in a local foundry and was designed by acclaimed artist and Aldeburgh resident Maggie Hambling (*see* below).

It was announced in 2022 that fundraising had begun for a statue of Benjamin Britten in Lowestoft to be created by Ian Rank-Broadley, who made the Princess Diana statue at Kensington Palace. It will depict Britten as a fourteen-year-old boy looking out to sea close to his birthplace and is expected to cost nearly £100,000.

Christopher Cockerell

Forever associated with the invention and development of the hovercraft, Christopher Cockerell was born in Cambridge on 4 June 1910. After attending Gresham's School in Norfolk, from 1924 until 1928, he studied mechanical engineering at Peterhouse, Cambridge. He then worked for a while at W. H. Allen & Sons of Bedford, before studying radio and electronics at Cambridge in 1934. The following year he worked for the Radio Research Company, before moving swiftly on to the Marconi Company.

After the end of the Second World War, Cockerell left Marconi and purchased a small company called Ripplecraft Ltd. It was during this time that he first developed ideas for what would become the hovercraft – a vehicle which could glide above the surface of the water on a cushion of air. Early trials took place at the pond in the grounds of Somerleyton Hall, situated north-west of Lowestoft. When, after several years of testing, the inventor presented a working balsa wood model to the British government in 1955, it was promptly placed on a secret list. This meant that Cockerell could not even discuss his invention openly until the classification was lifted in 1958. In the autumn of that year, an order for a full-size prototype was placed by the National Research Development Council (NRDC) with the firm Saunders-Roe. This machine, the SR.N1, was unveiled in June 1959 and made a successful crossing of the English Channel the following month. Cockerell was appointed Technical Director of Hovercraft Development Ltd – a subsidiary of the NRDC – and 'Hovercraft' became a registered trademark.

Cockerell's brainchild was steadily developed over the following decades, with large military and passenger-carrying versions being produced. The SR.N4 of 1972 was named the *Sir Christopher* and crossed the English Channel for the next nineteen years. The last two cross-channel hovercrafts, the *Princess Anne* and the *Princess Margaret*, were replaced by a pair of high-speed catamarans in October 2000.

Christopher Cockerell became a CBE in 1966 and was knighted three years later for services to engineering. He died at Hythe in Hampshire on 1 June 1999, three days short of his eighty-ninth birthday. A memorial roundel was unveiled on the pergola lawn at Somerleyton Hall in 2006. Also in Somerleyton, a monument in the form of a column topped with a bronze model of a hovercraft was installed in 2010. The official opening ceremony on 4 June 2010 was attended by the inventor's daughter, Frances Cockerell, and marked by a flypast by a Spitfire from the Battle of Britain Memorial Flight. This was

Left: Monument to Sir Christopher Cockerell, Somerleyton. *Right*: Somerleyton village sign.

in recognition of his work with the RAF during the Second World War, when he helped develop radio navigation systems. The column is around 20 feet (6 metres) tall and stands beside the B1074 St Olaves to Lowestoft road. Cockerell's workshop can be seen inside Lowestoft Maritime Museum at the Sparrow's Nest Gardens on Whapload Road, Lowestoft.

David Frost

Probably one of the most recognisable and influential people of the twentieth century, David Paradine Frost was born in Kent in 1939 but lived in Suffolk for part of his life. He moved from Northamptonshire to Beccles in 1958 when his father, the Revd W. J. Paradine Frost, was appointed Methodist minister there and superintendent minister of the Beccles, Loddon and Bungay district. David Frost almost followed in his father's footsteps by starting – but not completing – training to become a Methodist preacher. He became interested in drama at the Station Road Methodist Club in Beccles. Frost soon left the Suffolk town to study at Gonville and Caius College, Cambridge, but returned on numerous occasions to visit his parents. His father died in 1967 but his mother continued to live in Beccles and was actively involved in charity work until shortly before her death in 1991.

David Frost's first television job was at Anglia TV in an edition of *Town and Gown*. He made his name as presenter of the BBC's pioneering comedy satire show *That Was the Week That Was* (often shortened to *TW3*) in 1962–63, before moving to ITV for *The Frost Programme*. From 1968 to 1980, Frost worked in the USA. His most famous interviews

Beccles town centre.

were with disgraced former president Richard Nixon, these forming the basis for the *Frost/Nixon* film released in 2008. He also wrote a number of non-fiction books including *An Autobiography, Part 1: From Congregations to Audiences* (1993).

David Frost was appointed an OBE in 1970 and received a knighthood in 1993. He was twice married, firstly to Peter Sellers' widow Lynne Frederick between 1981 and 1982 and then to Lady Carina Fitzalan-Howard, daughter of the 17th Duke of Norfolk, from 1983 until his death. The couple had three children. Frost passed away suddenly aged seventy-four from a heart attack while aboard the MS *Queen Elizabeth* cruise ship on 31 August 2013. He is buried in a churchyard in Nuffield, Oxfordshire.

Cartoonist Giles

Cartoonist Ronald Giles, better known as Carl Giles or simply as Giles, lived in Suffolk for over fifty years. He and his wife Sylvia moved to Tuddenham near Ipswich soon after their wedding in 1942 and purchased Hillbrow Farm at nearby Witnesham four years later. Giles first produced cartoons for the *Reynolds News* Sunday newspaper from 1937 until 1943. He then worked for the *Daily Express* until 1989 and the *Sunday Express* until 1991. He became Britain's highest-paid cartoonist and received an OBE in 1959.

Giles Circus and Statue, Ipswich. (© David Smith, CC-BY-SA/2.0, geograph.org.uk)

A bronze statue of 'Grandma' and other characters from his popular comic strip was unveiled in Ipswich town centre in 1993 by actor Warren Mitchell. Giles, who had both legs amputated in 1990, attended the ceremony in a wheelchair. The statue was repositioned after changes to the road layout in 2010 and looks up at a window in the newspaper offices where Giles was employed. The area is now known as Giles Circus. The cartoonist died at Ipswich Hospital aged seventy-eight on 27 August 1995. He is buried in Tuddenham churchyard.

Maggi Hambling

Born in Sudbury in 1945 and raised in Hadleigh, artist Maggi Hambling has already been mentioned as the designer of *Scallop*, the Benjamin Britten tribute sculpture on Aldeburgh beach, which won the Marsh Award for Excellence in Public Sculpture in 2005. Sadly it is one of the most vandalised pieces of public art, having been attacked on many occasions over the last two decades. It still divides opinion with some saying that it is located in the wrong place and spoils the view and others regarding it as a unique and thought-provoking asset to Aldeburgh. For what it's worth, I am firmly in the latter camp!

The youngest of three children, Maggi Hambling studied art at the Amberfield School in Nacton near Ipswich, the East Anglian School of Painting and Drawing, the Ipswich School of Art, Camberwell College of Arts, and the Slade School of Art. Her painting *Head of Christ* hangs on the north wall inside St Mary's Church in Hadleigh. She accepted an OBE in 1995 and a CBE in 2010, both for services to painting. Her father, Harry Hambling, was a local politician who in retirement became a respected artist in his own right.

Scallop sculpture by Maggi Hambling CBE, Aldeburgh beach.

Other Modern Personalities

One of the twentieth century's most popular British artists, Beryl Cook (née Lansley, 10 September 1926–28 May 2008), briefly lived in Suffolk when she and her husband John ran a public house in the genteel village of Stoke-by-Nayland in Constable's Dedham Vale. They acquired the White Horse Inn after Mr Cook retired from the merchant navy in 1955. Apparently they found life there too quiet for their liking, having become accustomed to busy city living, and gave up the tenancy the following year.

Television cook and author Delia Smith lives near Stowmarket. She made the cake featured on the cover of the album *Let It Bleed* by The Rolling Stones in 1969 and for many years has been joint majority shareholder of Norwich City Football Club with her husband, Michael Wynn-Jones.

Former Conservative Party MP Norman Tebbit moved to Bury St Edmunds with his wife Margaret in 2009. Mrs Tebbit was seriously injured in the IRA bombing of Brighton's Grand Hotel in 1984 and was confined to a wheelchair until her death aged eighty-six in December 2020. Mr Tebbit, who was less seriously injured in the blast, continued to reside in the town following his wife's passing.

Martin Bell, author, journalist, former newsreader, war reporter and MP, was born in Redisham, Suffolk, in 1938 and has strong links with the town of Beccles. Often known as the 'Man in the White Suit', Martin Bell was appointed UNICEF Ambassador for Humanitarian Emergencies in 2001.

Television and radio presenter and journalist Bill Turnbull moved to Suffolk in 2016. He soon became involved with events in his local community and campaigned against the Sizewell C project. He died at his home from cancer aged sixty-six on 31 August 2022.

Former Formula 1 motor racing boss Bernie Ecclestone was born at Hawk House in the Suffolk village of St Peter South Elmham in 1930 and raised in Bungay.

Stoke-by-Nayland.

6. Film and Television Locations and Connections

Suffolk has appeared on screen on numerous occasions, in such films as *Yesterday*, *Harry Potter and the Deathly Hallows*, *Fourth Protocol*, *Lara Croft: Tomb Raider* and *Witchfinder General*. Television appearances include *Dad's Army*, *Lovejoy*, *The Crown* and *Detectorists*. This chapter takes a look at some of the locations used in these and many other productions, plus places associated with actors and other media figures with strong connections to the county.

Film and TV Personalities with Suffolk Links

Actor Ralph Fiennes was born in Ipswich in 1962 and has appeared in many films including *Schindler's List* (1993), *The English Patient* (1996) and *The Constant Gardener* (2005). He also famously played the evil Lord Voldemort in several *Harry Potter* films. The eldest of six children, his siblings include fellow actor Joseph Fiennes, director Martha Fiennes and film-maker Sophie Fiennes.

Robin Ellis, who was born in Ipswich in 1942, played Captain Ross Poldark in the original BBC drama series *Poldark* (1975–7). The role propelled him to almost overnight fame and he returned to play the Revd Dr Halse in the successful remake of *Poldark* (starring Aidan Turner in the title role) between 2015 and 2019. He also appeared in an episode of *Fawlty Towers*, as Howard Carter in *The Curse of King Tut's Tomb* (CBS mini-series, 1980), and opposite American actress Lee Remick in the 1979 film *The Europeans*.

Actor Bill Nighy, well known for such films as *Love Actually* (2003), *Shaun of the Dead* (2004), *The Boat That Rocked* (2009), *Harry Potter and the Deathly Hallows Part 1* (2010) and the *Pirates of the Caribbean* series, has a home in Aldeburgh. He has also declared his undying love for Dunwich and Walberswick and is said to frequently attend events across Suffolk.

Actress Miranda Raison, who was born in Norfolk and started acting while studying at Felixstowe College, also resides in Aldeburgh and is a member of the local golf club. She currently plays the part of journalist Ruth Penny in *The Sister Boniface Mysteries*, first transmitted on Britbox and the UKTV Drama channel in 2022. Earlier roles include Tallulah in *Dr Who* (2007), Marianne Faithfull in the TV film *Suzy Q* (1998), and appearances in episodes of *Emmerdale*, *Heartbeat* and *The Inspector Lynley Mysteries*.

Sir John Mills (22 February 1908–23 April 2005) was born in Norfolk and moved with his family to 9 Gainsborough Road, Felixstowe, in the early 1920s. He was educated at Sir John Leman High School in Beccles and at schools in Norwich and London. On completing his education he worked for a corn merchant in Ipswich. It was while living in Felixstowe that Mills first discovered his love for acting, initially on an amateur basis before later turning professional. He went on to become one of the world's most famous actors and appeared in over 100 films. He was appointed a CBE in 1960 and received a knighthood in 1976. The Sir John Mills Theatre in Ipswich was named in his honour.

Aldeburgh's historic Moot Hall.

Actress June Brown, who became a household name as Dot Cotton in the BBC soap *Eastenders* from 1985 to 1993 and again from 1997 to 2020, was born in Needham Market near Stowmarket on 16 February 1927. She attended St John's Church of England School in Ipswich and Ipswich High School. Brown was appointed an MBE in 2008 and an OBE in the 2022 New Year Honours, both in recognition of her services to drama and charity. She died aged ninety-five on 3 April 2022.

Actor Brian Capron, who became famous as *Coronation Street* villain Richard Hillman, was born in the picturesque Suffolk market town of Eye in February 1947. Capron played the serial killer in the ITV soap in 2001–3, and has also appeared in other television shows including *Grange Hill* (1980–3), *Eastenders*, *Z-Cars*, *The Bill*, *The Sweeney*, *Casualty* and many more. His film appearances include *Emma* (1996), *101 Dalmatians* (1996), *Still Crazy* (1998) and *Ambleton Delight* (2009). Capron toured alongside Claire Sweeny in the musical *Guys and Dolls* in 2007 and was a contestant on the fifth series of the BBC's *Strictly Come Dancing*. The ruined Eye Castle – actually a nineteenth-century folly – stands on a mound opposite St Peter and St Paul's Church and provides good views of the town.

Actor Bob Hoskins was born in Bury St Edmunds on 26 October 1942, due to his family being evacuated to Suffolk during the London blitz. They returned to the Finsbury Park

Needham Market town sign. (© Adrian S Pye, CC-BY-SA/2.0, geograph.org.uk)

St Peter and St Paul's Church, Eye.

area while he was still a baby. His best-known films include *The Long Good Friday* (1980), *Mona Lisa* (1986), *Who Framed Roger Rabbit* (1988) and *Mermaids* (1990). He passed away from pneumonia on 29 April 2014 and is buried in Highgate Cemetery.

Sir Peter Hall CBE (1930–2017), founder of the Royal Shakespeare Company, was also born in Bury St Edmunds. During his long career he directed the National Theatre, Glyndebourne, and The Peter Hall Company. He was the first to produce Samuel Beckett's play *Waiting for Godot* in 1955, and also made a film based on the book *Akenfield: Portrait of an English Village* in 1974.

Actor, comedian and presenter Griff Rhys Jones has a home in the village of Holbrook by the River Stour on the Shotley Peninsula, around 5 miles south of Ipswich. He rose to fame in the BBC comedy series *Not the Nine 'O'clock News* (1979–82) alongside Rowan Atkinson, Mel Smith and Pamela Stephenson.

Sir Clement Freud, a politician, broadcaster, celebrity television chef and author, died aged eighty-four at his home in Walberswick on 15 April 2009. He was the brother of artist Lucien Freud and a grandson of psychoanalyst Sigmund Freud. Clement Freud's wife, actress Jill Raymond, ran a local theatre company for many years. Their daughter, broadcaster Emma Freud, has a home in the village with her partner, successful screenwriter Richard Curtis.

German supermodel Claudia Schiffer lives with her film director husband Matthew Vaughn at Coldham Hall, Stanningfield, near Bury St Edmunds. They purchased the Grade I listed Tudor mansion, which is said to have fourteen bedrooms and 530 acres of land, in 2002.

Twiggy (real name Lesley Lawson, née Hornby) was arguably the original supermodel as a teenager in the 1960s. Also an actor and singer, for many years she and her husband Leigh Lawson, an actor, director and writer, have owned a home in Southwold. Twiggy became a Dame (DBE) in the 2019 New Year honours.

Popples Farm in Brettenham near Lavenham is the country home of actors Kit Harington and Rose Leslie. The couple, who married in 2018, played the parts of Jon Snow and Ygritte in the hugely popular *Game of Thrones* series. The fifteenth-century mansion had a hefty £1.75 million price tag when Harington purchased it in 2017.

Don't tell him, Pike! – *Dad's Army* Secrets

Dad's Army, one of the best-loved British television comedy series, ran from 1968 until 1977 on BBC TV. Starring Arthur Lowe, John Le Mesurier, Clive Dunn, John Laurie, Arnold Ridley and Ian Lavender in the leading roles, the working title was *The Fighting Tigers*. The outdoor filming mainly took place in Suffolk and Norfolk, with the town of Thetford and the Stanford Training Area (STANTA) appearing on a regular basis.

A working windmill was required for the 'Don't forget the Diver' episode in 1970, where Corporal Jones (Clive Dunn) climbs up on the sails to stop them revolving and is flung into a nearby river. After much searching, Clover's Post Mill in Drinkstone, Suffolk, which still had all four sails attached, was chosen as the ideal filming location. However, as director Harold Snoad revealed in an interview in 2011, there was a problem when it was discovered that the mill's sails were unable to turn by wind power. Mr Snoad's clever solution was to erect a temporary hut with front and sides but no back. Hidden from view

were 'two scene boys inside who are pulling the blades of the windmill round', giving the impression of a working mill. The hut is clearly visible on screen but its purpose remained a secret for over forty years. Unlike many of its ilk, Clover's Post Mill is still standing but has lost its sails. Two were still in place in 2002 but a planned full restoration fell through when the owners moved away.

Thetford Guildhall played the part of fictional Walmington-on-Sea Town Hall and Lowestoft was used in episodes where coastal scenes were required. On screen they were part of the same seaside town but in reality the two locations are over 50 miles apart by road. Other Suffolk locations include Brandon, Sapiston, the Six Bells Inn at Bardwell, All Saints' Church and V. C. Primary School in Honingham, and the sugar beet factory in Bury St Edmunds. A seated statue of Captain Mainwaring (played by Arthur Lowe) was erected by the river in Thetford in 2010.

Clover's Post Mill at Drinkstone once appeared in *Dad's Army*.

The author meets Captain Mainwaring over the 'border' in Thetford. (© John Middleton)

Lovejoy: Antiques and Antics

The popular BBC TV drama series *Lovejoy* ran for six series and seventy-one episodes between 1986 and 1994. It starred Ian McShane as the eponymous antiques dealer with Caroline Langrishe as Charlotte Cavendish and Phyllis Logan, who would much later find wider fame as Mrs Hughes in *Downton Abbey*, as Lady Jane Felsham. Other cast members

The village of Debenham.

included Dudley Sutton, Chris Jury and Malcolm Tierney. The show's entertaining plots were cleverly woven around the antiques business and the often spectacular Suffolk countryside.

Many Suffolk locations were used over the years including Lavenham, Long Melford, Bury St Edmunds, Clare, Newmarket and Debenham. The interior of the Bull Hotel in Long Melford was featured a number of times, while the fictional Felsham Hall was actually Belchamp Hall in Essex. The final episode was titled 'Last Tango in Lavenham'.

Yesterday (2019 film)
The successful movie *Yesterday* was largely filmed in Suffolk and neighbouring Norfolk. Written by Richard Curtis (who has a home in Walberswick) and directed by Danny Boyle, it explores a strange world where almost nobody can remember The Beatles. Himesh Patel plays struggling singer-songwriter Jack Malik, who works in a warehouse in Lowestoft. After a road accident during a temporary global power cut, he is blessed and cursed in equal measure as one who can remember the 'Fab Four'. He pretends that their songs are his own and becomes incredibly famous but, after meeting a woman from Liverpool named Liz (Sara Lancashire) who also knows his secret, he finally comes clean and admits that he is a fraud. Other stars of the film include Suffolk's favourite adopted son Ed Sheeran as himself, Lily James, Sanjeev Bhaskar, Meera Syal, and an unaccredited Robert Carlyle as a seventy-eight-year-old John Lennon.

The Ramsholt Arms public house. (© Geographer, CC-BY-SA/2.0, geograph.org.uk)

Filming began in April 2018 and the movie was rush-released in June 2019. Suffolk locations include Lowestoft, Dunwich, Shingle Street, Halesworth and the Latitude Festival near Southwold. The song 'Yesterday' is first played outside the Ramsholt Arms public house near Woodbridge. The famous beach scene was filmed at Gorleston, just over the boundary between Suffolk and Norfolk. The film appears to have boosted the profile of both counties and attracted additional tourists to the region.

Lavenham: From John and Yoko to Harry Potter

In addition to being a main location for the television series *Lovejoy*, Lavenham has appeared on screen on many other occasions. It is considered to be the best-preserved medieval village in England and is perhaps most familiar to twenty-first-century film-goers as the fictional Godric's Hollow in *Harry Potter and the Deathly Hallows Parts 1 and 2* (2010/11). De Vere House became the title character's birthplace while the Guildhall masqueraded as the former home of his late parents. To the disappointment of local fans, Daniel Radcliffe, who of course played Harry Potter in all of the movies, was absent along with the rest of the cast. They were magically united with the buildings of Lavenham by some extraordinary trickery worthy of Potter himself.

Lavenham is a magnet for film crews.

Many years before author J. K. Rowling created her phenomenally successful boy wizard, two of the most famous faces of the twentieth century used Lavenham as a location for their experimental art film *Apotheosis*. John Lennon and Yoko Ono rocked up in Market Square in December 1969, and were filmed climbing into the basket of a hot-air balloon. It then ascended into the cold winter sky above a snowy Suffolk with the controversial couple seemingly onboard. Contrary to appearances, however, they disembarked before take-off and remained earthbound in the opulence of Lennon's chauffeur-driven white Rolls-Royce Phantom V limousine. Slightly unimaginatively, they booked in at the Bull Hotel in nearby Long Melford as 'Mr and Mrs Smith'. The seventeen-minute-long film was shown at the Cannes Film Festival in 1971. Speaking over forty years later, Yoko Ono Lennon fondly recalled her visit to Lavenham and expressed a wish to return one day, but conceded that it could never be the same without her late husband who was murdered in New York City in 1980.

The violent historical horror film *Witchfinder General* (1968) was partly shot in Lavenham, along with other locations including Bury St Edmunds, Orford Castle, Kentwell Hall in Long Melford, Dunwich, and the Stanford Training Area (STANTA) near Thetford. It starred American actor Vincent Price as Matthew Hopkins (*c.* 1620–47), who was responsible for the torture and deaths of hundreds of alleged witches across East Anglia during the English Civil War. Vincent Price and the film's young English director, Michael Reeves, were at loggerheads during much of the shoot. Reeves, who died aged twenty-five from an accidental overdose of barbiturates and alcohol on 11 February 1969, made no secret of the fact that Price was not his choice to play the lead role. The film still divides opinion.

Barry Lyndon (1975), written, directed and produced by Stanley Kubrick, was partly filmed at Lavenham Guildhall plus many other locations across England, Ireland, Scotland and Germany. The movie starred Ryan O'Neal.

Several television travel shows and documentaries have featured Lavenham, one of the most recent being *Pubs, Ponds and Power: The Story of the Village* (BBC, 2019), presented by archaeologist Ben Robinson.

Ipswich Area

As the county town of Suffolk, Ipswich has been a film location on many occasions. *The Angry Silence* (1960) featured Richard Attenborough as a worker who takes a lonely stand against an unofficial strike that he disagrees with. Filming took place at the factory of local firm Ransomes and Rapier.

Ipswich Town Football Club's Portman Road ground was used for match scenes in *Yesterday's Hero*, a 1979 film loosely based on the life of George Best. The lead role of an alcoholic ex-footballer was played by Ian McShane, later to become a household name as the title character in the *Lovejoy* series.

Fourth Protocol (1987), starring Michael Caine as a British agent at the height of the Cold War, was partly filmed in Ipswich. An adaptation of Frederick Forsyth's novel of the same name, it features a spectacular sequence where helicopters fly through the legs of the Orwell Bridge and land on the quayside in Ipswich.

The Orwell Bridge from Wherstead Hall Farm. (© Geographer, CC-BY-SA/2.0, geograph.org.uk)

Trenches on land just outside of Ipswich have been used for realistic fighting scenes on several occasions. The film *Private Peaceful* (2012), about two farming brothers conscripted during the First World War, was partly shot there, as was *Stanley's War* (2018). Combat scenes for the highly successful *Downton Abbey* TV series were filmed at the same location. The trenches are on private land and are not accessible to the public.

The BBC series *Jimmy's Farm*, first aired in 2004, was recorded at Jimmy Doherty's rare breed pig farm and visitor attraction at Wherstead on the Shotley Peninsula, 3 miles south of Ipswich. More recently the farm has been featured in various Channel 4 programmes.

Lowestoft Area

In addition to appearances in *Dad's Army* and the movie *Yesterday*, Lowestoft was featured in the 'Race against God' challenge during an edition of the BBC TV series *Top Gear* (series 16, episode 6). Presenter Jeremy Clarkson's task was to drive a Jaguar XJ 5.0 V8 Supersport through the night from Britain's most westerly mainland point, Land's End in Cornwall, to Ness Point, Lowestoft, before the sun rose the following morning. The stunt took place on the shortest night of the year, 21 June 2010, and Clarkson completed the 435-mile journey in six hours and fifty-seven minutes, arriving at his destination

'Gulliver', Lowestoft.

just five minutes before the sun came up over Ness Point. The episode was first aired on 27 February 2011. An enormous lone wind turbine – named 'Gulliver' following a poll of local residents – dominates the area and was seen to great effect on the show. When built in December 2004, it was for a while the country's largest onshore wind turbine. It stands 262.5 feet (80 metres) tall to the rotor hub, and with blades measuring 302 feet (92 metres) in diameter has a total height of 413.4 feet (126 metres).

Lowestoft's Ness Point – officially the most easterly point in mainland Britain – has been marked since the 1990s by a large disc called the 'Euroscope'. This shows the distance from Ness Point to various places in Britain including Land's End and John o'Groats, plus European destinations.

Somerleyton Hall, located a few miles north-west of Lowestoft, was extensively used for external and internal sequences in the controversial fourth series of *The Crown* (Netflix) in 2020. It successfully stood in for Sandringham House in many scenes featuring Queen Elizabeth II (played by Norfolk-born Olivia Colman), Princess Margaret (Helena Bonham Carter), Prince Charles (Josh O'Connor) and Princess Diana (Emma Corrin). The building is similar in appearance to the royal Norfolk residence and filming took place just before the start of the first coronavirus lockdown in March 2020. The hall's own carpets and furniture were temporarily removed and the crew brought in lorry loads of

The 'Euroscope', Ness Point, Lowestoft.

Somerleyton Hall, *c*. 1970. (Joan Ling)

furniture and props. The building was repainted and trees and decorations were put up to recreate Christmas at Sandringham House. A scene showing a dancing Diana was shot in the ballroom. Somerleyton Hall is the family home of Lord and Lady Somerleyton and the gardens are normally open to the public on some days each week between Easter and the end of October. At the time of writing the hall's interior is not accessible to the public.

Southwold Area

Future Monty Python star and globetrotting presenter Michael Palin spent annual seaside holidays with his family in Southwold during the 1950s. Many years later his adolescent memories inspired *East of Ipswich*, a BBC TV drama filmed in Southwold and first shown in 1987. The story is a semi-autobiographical account of Richard and Julia, two teenagers holidaying in separate Southwold guest houses with their families. Palin met his future wife Helen in the town in 1959.

The movie *Iris* (2001), based on the life of author and philosopher Iris Murdoch (15 July 1919–8 February 1999), was partly shot on Southwold beach. The town was one of her favourite places but her later years were blighted by Alzheimer's disease. The film starred Judi Dench and Kate Winslet as Murdoch in different stages of her life, while her husband John Bayley was portrayed in later years by Jim Broadbent and in earlier times by Hugh Bonneville. The cast also included father and son actors Timothy and Samuel West.

Just over the river from Southwold, Walberswick is a short ferry boat trip but a 9-mile road journey. Victorian artist Phillip Wilson Steer fell in love with the place and made

The town of Southwold.

annual visits. He set up an artists' colony in the village and his story was told in *The Bridge* (1992), a film based on Maggie Hemingway's novel. Lead actors included Saskia Reeves, David O'Hara and Joss Ackland.

Walberswick was one of a number of Suffolk locations visited in an East Anglian edition of *Penelope Keith's Coastal Villages* (Channel 4, 2017). She also called at Blythburgh Church to inspect the alleged claw marks of the legendary Black Shuck, explored the remains of ancient Dunwich, and spent time in Thorpeness. Presenter Ben Robinson devoted editions of his *Villages by the Sea* series (BBC, 2019–22) to Walberswick, Thorpeness and Orford.

The tiny village of Covehithe, situated around 4 miles north of Southwold, was a location for the BBC TV adaptation of *Death in Holy Orders* (2003) by P. D. James. It starred Martin Shaw as Commander Adam Dalglish and was partly filmed at St Andrew's Church. Originally built in the fourteenth and fifteenth centuries, the large church was partially dismantled in the 1670s. A much smaller new church was constructed but the original tower and much of the outer stonework was left in place. Once several miles inland, the church is getting ever closer to the cliff edge due to coastal erosion. A local legend claims that the churchyard is haunted by a faceless ghost known as the White Lady.

Above: Walberswick Ferry.

Left: St Andrew's Church, Covehithe.

The early Monty Python sketch 'The First Man to Jump the Channel' (BBC TV, series 1, episode 10) was partly shot on Covehithe beach. It was first transmitted in October 1969.

An adaptation of Charles Dickens's *David Copperfield* was broadcast on BBC TV in two parts on Christmas Day and Boxing Day 1999. A boat scene was filmed on the beach at either Covehithe or nearby Benacre. The all-star cast included Emilia Fox, Maggie Smith, Ian Mckellen, Bob Hoskins, Nicholas Lyndhurst and Trevor Eve, plus a ten-year-old Daniel Radcliffe in his first acting role as young David.

Some scenes for the long-running BBC TV drama series *Jonathan Creek*, starring Alan Davies, were filmed at Wangford and Wrentham, near Southwold. However, those hoping to find Creek's famous windmill will be disappointed as it is located at Shipley in West Sussex.

Bury St Edmunds

In addition to appearances in *Witchfinder General* and the *Lovejoy* television series, Bury St Edmunds was a location for the movie *The Personal Life of David Copperfield*. Scenes were filmed on Angel Hill and outside the Angel Hotel in the town centre in July 2018. Written and directed by Armando Iannucci, it is a quirky take on the classic story by Charles Dickens, who stayed at the Angel Hotel on three separate occasions. The Theatre Royal on Westgate Street was used for interior shots and other locations include the Athenaeum, where the famous author gave readings of his books in 1859 and 1861, Crown Street, Churchgate Street and Chequer Square. David Copperfield was played by Dev Patel, with Peter Capaldi as Mr Micawber, Daisy May Cooper as Peggotty,

The Angel Hotel, Bury St Edmunds.

Paul Whitehouse as Mr Peggotty, Ben Wishaw as Uriah Heep, Hugh Lawrie as Mr Dick and Tilda Swinton as Betsey Trotwood. Filming also took place in neighbouring Norfolk and further afield.

Actor Pierce Brosnan stayed at the Angel Hotel while filming *Tomorrow Never Dies* in Suffolk in 1997. The RAF bases at Mildenhall and Lakenheath were key locations for the eighteenth movie in the James Bond franchise. Over fifty personnel from the bases appeared as extras and a helicopter crew from the USAF Special Operations Group took part in the action scenes.

Other Locations

The attractive village of Kersey near Hadleigh has long been a favourite of photographers and film crews. Most recently it became the backdrop for an adaptation of Anthony Horowitz's *Magpie Murders*. Lead actors Timothy Spall, playing the part of Atticus Pund, and Lesley Manville filmed in Kersey during April and May 2021. Church Hill Road was closed each day over a two-week period and the fourteenth-century Bell Inn was temporarily renamed the Queen's Arms. Timothy Spall later pulled out of the production and was replaced by Tim McMullan. The series was first aired on BritBox UK and Masterpiece PBS in 2022.

Above left and above right: Kersey.

An episode of *Dr Who* called 'The Power of Kroll' was shot on location in Suffolk in September 1978. A film crew spent nine days by the River Alde and adjacent marshes in Snape, which substituted for an alien planet with inhabitants called 'Swampies'. Snape was also used as a location for *The Dig* (2021), along with other places in the area including Iken, Butley and Rendlesham Forest. The film, which starred Carey Mulligan and Ralph Fiennes, told the true story of the sensational discovery of a ship burial beneath mysterious mounds at Sutton Hoo in the 1930s. The actual site is under the care of the National Trust and the burial mounds shown on screen had to be specially built at a location in Surrey.

Thorpeness, situated just north of Aldeburgh, was mentioned earlier due to its links with author J. M. Barrie. It was also used as a location for the film *Drowning by Numbers* (1988), a murder story starring Bernard Hill, Joan Plowright, Juliet Stevenson and Joely Richardson. Several television programmes have also showcased this unique place.

Elveden Hall near Thetford is a popular choice for film directors and has graced many a movie. In *Lara Croft: Tomb Raider* (2001), based on a video game character and starring Angelina Jolie in the lead role, it served as 'Croft Towers'. Stanley Kubrick used the hall to spectacular effect in his last movie *Eyes Wide Shut* (1999), featuring Tom Cruise and Nicole Kidman. Ridley Scott directed *All the Money in the World* (2017), based on the true story

The 'fantasy' village of Thorpeness.

of the 1973 kidnap of sixteen-year-old John Paul Getty III. Christopher Plummer played J. Paul Getty senior in the film, with Elveden Hall providing a suitably luxurious backdrop. Other film and television appearances include the James Bond movie *The Living Daylights* (1987), *Princess Caraboo* (1994), *Gulliver's Travels* (1996), *The Moonstone* (1997), *Stardust* (2007), *Dean Spanley* (2008), and *Agatha Christie's Poirot: Cat among the Pigeons* (2008).

The BBC comedy series *Detectorists*, which ran from 2014 till 2017, was filmed at several Suffolk locations including Framlingham, Orford, Sudbury and the Woodbridge area. It was written and directed by Mackenzie Crook, who also starred alongside Toby Jones and Rachel Stirling. The stories followed the adventures of metal detector operators and made good use of the Suffolk countryside.

The village of Orford and in particular the former top-secret MOD site at Orford Ness have featured in a number of television documentaries in recent years.

The 1996 film *The Wind in the Willows*, based on Kenneth Graham's children's classic first published in 1908, was partly filmed in Suffolk. The exterior of Kentwell Hall in Long Melford was used as Toad Hall in an all-star production featuring Terry Jones as Mr Toad, Steve Coogan as Mole and Eric Idle as Rat. Michael Palin, John Cleese, Stephen Fry, Victoria Wood and many others were also involved.

The River Alde at Orford with Orford Ness in the background.

7. Music Links and Inspirations

The Aldeburgh Festival

The world-famous Aldeburgh Festival was founded in 1948 by composer Benjamin Britten, singer Peter Pears and Eric Crozier, a librettist and producer. The Aldeburgh Jubilee Hall and the local parish church of St Peter and St Paul were the main venues for the first festival, which ran from 5 to 13 June that year. Other venues in Blythburgh, Framlingham and Orford were also used in later years before the festival acquired a permanent new home in 1967. The old maltings at Snape were acquired and the largest of the malthouses was converted to a concert hall capable of housing a full symphony orchestra. Queen Elizabeth II officially opened the Snape Maltings Concert Hall on 2 June 1967, but just two years later the building was gutted by fire on the first night of the 1969 festival. Amazingly, the venue was rebuilt in time for the 1970 season of concerts, and again the Queen was in attendance for the opening night.

Conductor, composer and arranger Imogen Holst, daughter of eminent composer Gustav Holst, moved to Aldeburgh in 1952 to work with Benjamin Britten. For twelve years she assisted him with his music before returning to composing in her own right.

The riverside at Snape Maltings.

A Henry Moore sculpture provides a seat for the author's parents at Snape Maltings.

From 1956 until 1977, she was an artistic director of the Aldeburgh Festival alongside Britten and Peter Pears. During this time she included many of her father's works alongside early choral music. Imogen Holst remained in Aldeburgh after retiring from the festival directorate and died on 9 March 1984 at the age of seventy-six. Like Britten and Pears, she is buried in the churchyard of St Peter and St Paul, as is singer Joan Cross, who after leaving the Sadler's Wells Company retired to Aldeburgh and passed away aged ninety-three on 12 December 1993.

Over the years, the Aldeburgh Festival has premiered a number of works by Britten including *A Midsummer Night's Dream* (1960) and *Death in Venice* (1973), and introduced the work of several new composers. Many pieces of art including sculptures by Henry Moore and works by Maggi Hambling and Brian Eno have also been exhibited. Apart from an unscheduled interruption due to coronavirus in 2020, the festival is still held annually.

The Latitude Festival
In addition to the Aldeburgh Festival, Suffolk is now famous for the Latitude Festival. Spread over three days and four stages, the event showcases music, poetry, art, comedy and theatre. With one exception the Latitude Festival has been held annually at Henham

The Latitude Festival in 2017. (© Alex Hogan)

Park, north of Blythburgh, since 2006. The 2020 event was cancelled due to the global pandemic but it returned the following year as the first full-capacity festival to be held in Britain since 2019.

Numerous diverse acts have appeared over the years including Pet Shop Boys (2009), Grace Jones (2009), Paul Weller (2012), Kraftwerk (2013), Noel Gallagher (2015), New Order (2016), The Killers (2018), George Ezra (2019), Lana Del Rey (2019) and Lewis Capaldi (2022), to name but a few.

Ed Sheeran

Suffolk and West Yorkshire both lay claims to one of the top-selling singer-songwriters of the twenty-first century. Superstar Ed Sheeran was born in Halifax in 1991 and spent his very early years in Hebden Bridge before his family moved to Framlingham in December 1995. He attended the Brandeston Hall Preparatory School and the Thomas Mills High School in Framlingham, where he began writing songs. The University of Suffolk awarded him an honorary degree in 2015 for his 'outstanding contribution to music'.

Ed Sheeran married Cherry Seaborn, a former classmate, in 2019, and their first child was born the following year. The singer has stated that his song 'Perfect' was inspired by

Dennington village sign. (© Adrian S Pye, CC-BY-SA/2.0, geograph.org.uk)

his wife. Another hit, 'Castle on the Hill', recalls his years growing up in Framlingham and the title is a reference to the impressive fortress that dominates the town. Other hugely successful songs include 'The A Team', 'Shape of You' and 'The Joker and the Queen'. His total sales were said to have passed the 150 million mark by 2021.

Ed Sheeran supports Ipswich Town FC and was named as the team's home kit sponsor for the 2021/22 and 2022/23 seasons. He is reported to have spent in excess of £3.6 million on five properties in Dennington, 3 miles from Framlingham, to form a private estate known locally as 'Sheeranville'. The first, Wynneys Hall, was purchased in 2012 and the latest was acquired in 2019. The estate, which now includes a recording studio, private pub, gym, indoor swimming pool and a wildlife pond, is surrounded by tall fencing and hedging.

Brian Eno

Electronic music pioneer, composer and producer Brian Eno was born in Melton near Woodbridge in 1948. He attended St George's College, Ipswich, and the Ipswich School of Art in the 1960s. Although he describes himself as a 'non-musician', he is famed for his radical synthesizer playing as an original member of Roxy Music. In addition to using the EMS VCS 3, he also contributed tape effects and vocals to the band's first two albums,

Dunwich beach.

Roxy Music (1972) and *For Your Pleasure* (1973). After leaving Roxy Music in 1973, mainly due to musical differences with songwriter and frontman Bryan Ferry, Eno became noted for his innovative solo recordings including various 'ambient' pieces. His native Suffolk has influenced some of his music including 'Dunwich Beach, Autumn, 1960', from the album *Ambient 4: On Land*. As an artist and co-composer he collaborated with David Bowie on the latter's 'Berlin Trilogy' albums *Low, Heroes* and *Lodger* (1977–79). As a producer he has worked with the likes of U2 and Coldplay.

The Darkness

The Darkness, formed in Lowestoft at the start of the present century, can lay claim to being Suffolk's most successful band. Their debut album, *Permission to Land*, was released in 2003 and became a huge hit. The opening track, 'Black Shuck', referenced the legendary hound said to haunt Suffolk and beyond. The song mentions Blythburgh, where the beast is claimed to have materialised during a thunderstorm in 1577. Another track from the album, 'I Believe in a Thing Called Love', reached number 2 in the British singles chart in 2003. 'Christmas Time (Don't Let the Bells End)' narrowly missed out on the UK Christmas number 1 slot that year.

After the departure of lead singer Justin Hawkins, The Darkness disbanded in 2006 but reformed in 2011. They are still recording and touring, though various line-up changes have occurred over the years.

Lowestoft beach.

Other Connections

Radio One DJ John Peel (real name John R. P. Ravenscroft) moved to Great Finborough near Stowmarket during the 1970s and lived in a property he referred to as 'Peel Acres' with second wife Sheila, for the remainder of his life. He died in Cusco, Peru, on 25 October 2004 from a heart attack, aged sixty-five. Over a thousand mourners attended his funeral in Bury St Edmunds on 12 November 2004, after which he was buried in the churchyard of St Andrew's, Great Finborough. Peel's favourite song, 'Teenage Kicks' by punk rockers The Undertones, was played at the end of his funeral service and lyrics from the song, 'Teenage dreams, so hard to beat', were inscribed on his gravestone in 2008. The former Stowmarket Corn Exchange is now the John Peel Centre for Creative Arts.

Jack Bruce, the legendary rock bassist and singer who with Eric Clapton and Ginger Baker formed the late 1960s supergroup Cream, lived near Sudbury in his later years. He died aged seventy-one from liver disease at his home on 25 October 2014.

Singer Dina Carroll was born in Newmarket in 1968. She enjoyed many British hit singles during the 1990s, including 'It's Too Late' (with Quartz, no. 8 in 1991), 'Don't Be a Stranger' (no. 3, 1993), 'The Perfect Year' (no. 5, 1993) and 'Escaping' (no. 3, 1996). She also had success with the albums *So Close* (1993) and *Only Human* (1996), which both reached no. 2 in the UK albums chart.

Suffolk band Cradle of Filth has built a cult following since coming together in 1991. Their music is generally described as Gothic-inspired extreme metal, though lead

Much of ancient Dunwich lies beneath the waves.

vocalist Dani Filth – the sole founder-member still with the band – insists that they defy categorisation.

Another Suffolk group, The Future Kings of England, were formed in Ipswich and have been active since 2003. Their 2007 album *The Fate of Old Mother Orvis*, opens with a track called 'Dunwich', about the former town and seaport which once had up to 5,000 citizens but is now a small village with a population of fewer than 200. The front cover artwork features a long-vanished church precariously perched on the cliff edge.

Singer-songwriter Al Stewart, best-known for his classic song 'Year of the Cat', referenced the old legend of church bells tolling beneath the sea at Dunwich in his 1993 composition 'The Coldest Winter in Memory'.

Ruins of Greyfriars Friary, Dunwich.

Bibliography

Geographia, *Guide to East Anglia* (London: Geographia Ltd)
Haining, Peter, *The Supernatural Coast: Unexplained Mysteries of East Anglia* (London: Robert Hale Ltd, 1992)
Ling, John, *Illustrated Tales of Suffolk* (Stroud: Amberley Publishing, 2020)
O'Brien, Rick, *East Anglian Curiosities* (Wimborne: The Dovecote Press Ltd, 1992)
Timpson, John, *Timpson's Travels in East Anglia* (London: William Heinemann Ltd, 1990)

Acknowledgements

The author would like to thank the following:

John and Rosalind Middleton and family, Alex Hogan, Adrian S. Pye, Adrian Cable, Roger Cornfoot, David P. Howard, David Smith, and Bungay Castle Trust.